Splash 1
America's Best
Watercolors

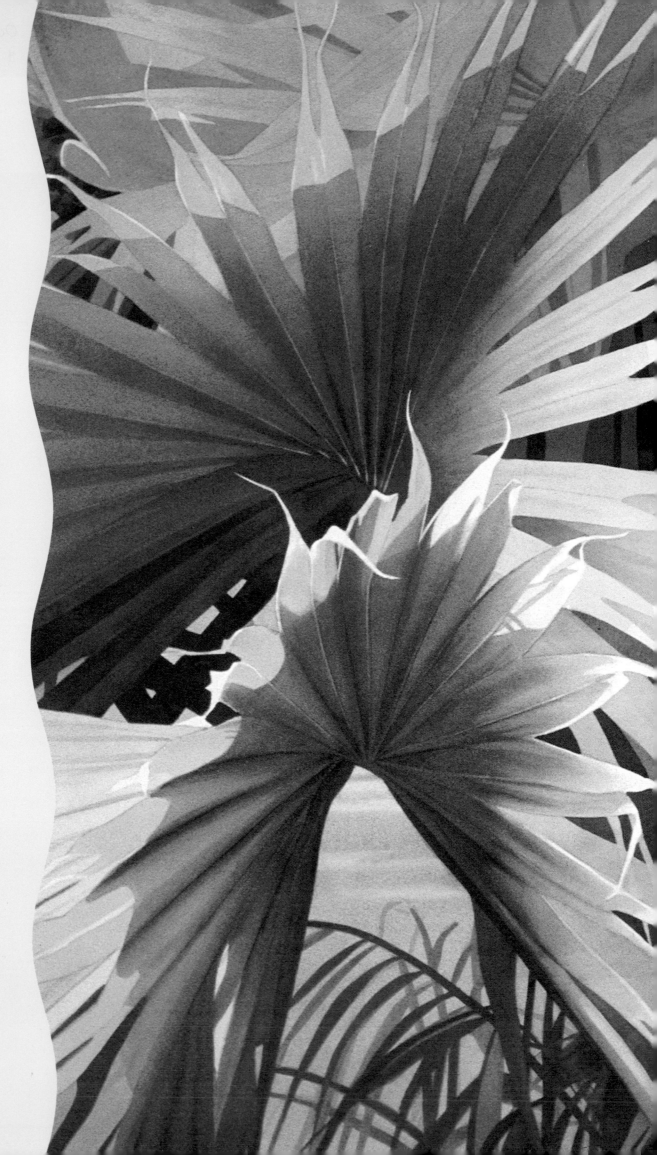

Splash 1 America's Best Watercolors

Edited by

Greg Albert
&
Rachel Rubin Wolf

NORTH LIGHT BOOKS

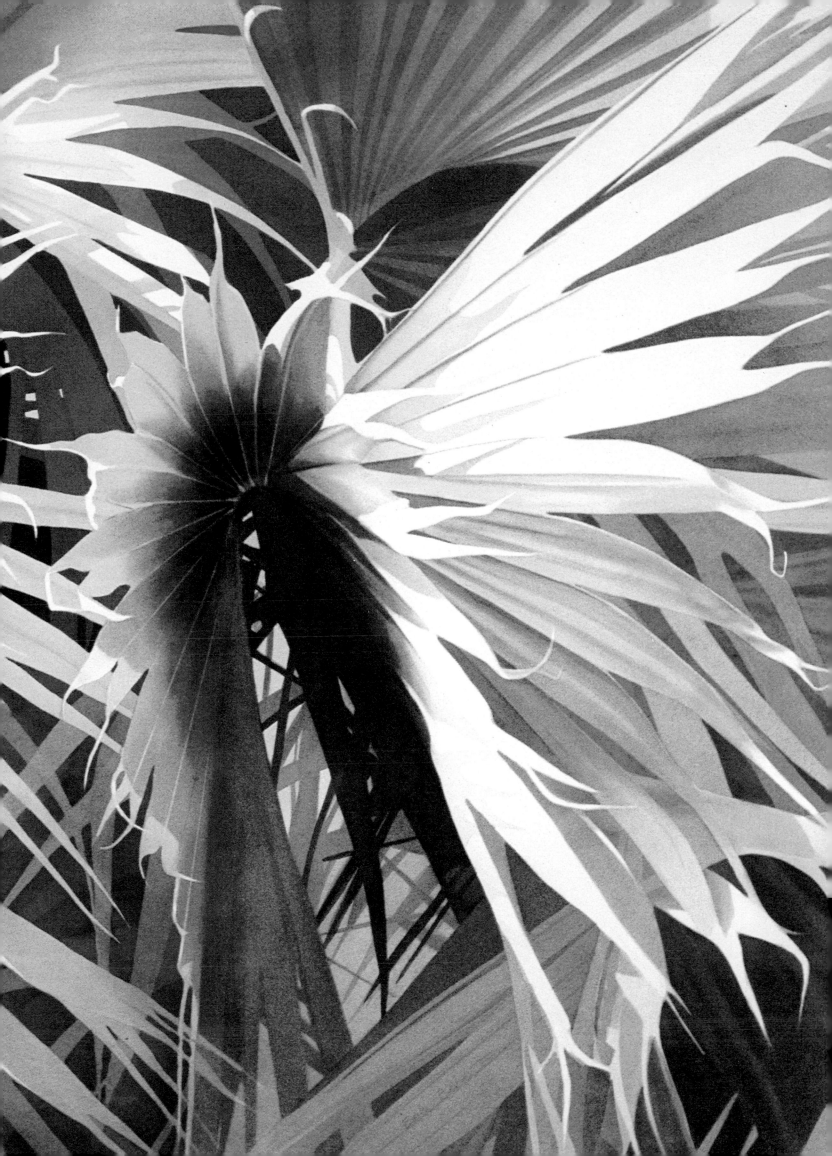

Previous page: *Palm Patterns #125*, Edith Bergstrom 34½" x 57¼"

Other fine North Light Books are available at your local bookstore, art supply store or direct from the publisher.

01 00 99 98 97 5 4 3 2 1

Library of Congress Cataloging-in-Publication Data
Splash 1 / project editors, Greg Albert and Rachel Wolf.
 p. cm.
 Includes index.
 ISBN 0-89134-849-2
 1. Watercolor painting, American. 2. Watercolor painting—20th century—United States.
I. Albert, Greg. II. Wolf, Rachel.
ND1808.S66 1990
759.13'09'048—dc20 90-7876
 CIP

Interior designed by Clare Finney
Pages 146-148 constitute an extension of this copyright page.

North Light Books are available for sales promotions, premiums and fund-raising use. Special editions or book excerpts can also be created to specification. For details contact: Special Sales Manager, F&W Publications, 1507 Dana Avenue, Cincinnati, Ohio 45207.

ABOUT THE EDITORS

Greg Albert is a graduate of the Art Academy of Cincinnati where he studied painting. He earned a Master of Fine Arts degree from the University of Montana and Master's Degree in Art History from the University of Cincinnati. Greg has been editing art instruction books for North Light Books since 1986. He paints in various mediums and teaches evening classes in drawing.

Rachel Rubin Wolf is a freelance writer and editor. She acquires and edits fine art books for North Light Books. Wolf is the project editor for the *Splash* series and for many of North Light's *Basic Techniques* series paperbacks, as well as *The Best of Wildlife Art*. She is the author of *The Acrylic Painter's Book of Styles and Techniques* and *Painting Ships, Shorelines and the Sea*.

Wolf studied painting and drawing at the Philadelphia College of Art (now University of the Arts) and Kansas City Art Institute. She continues to paint in watercolor and oils as much as time will permit.

CONTENTS

INTRODUCTION

We, the editors, have collected here what we feel are some of the finest examples of contemporary American watercolor paintings. We have included paintings from a wide range of styles and techniques; loose abstraction to tight realism, traditional transparent watercolor to various experimental techniques. We intend this volume to be both instructional and inspirational. We ourselves have been inspired, first, simply by looking at the works of art contained in this book, and second, by corresponding or speaking with each of the ninety artists represented here concerning their work. *Splash 1* is our tribute to the beauty and fun of watercolor.

Passages Too
Dee Knott
40" x 30"

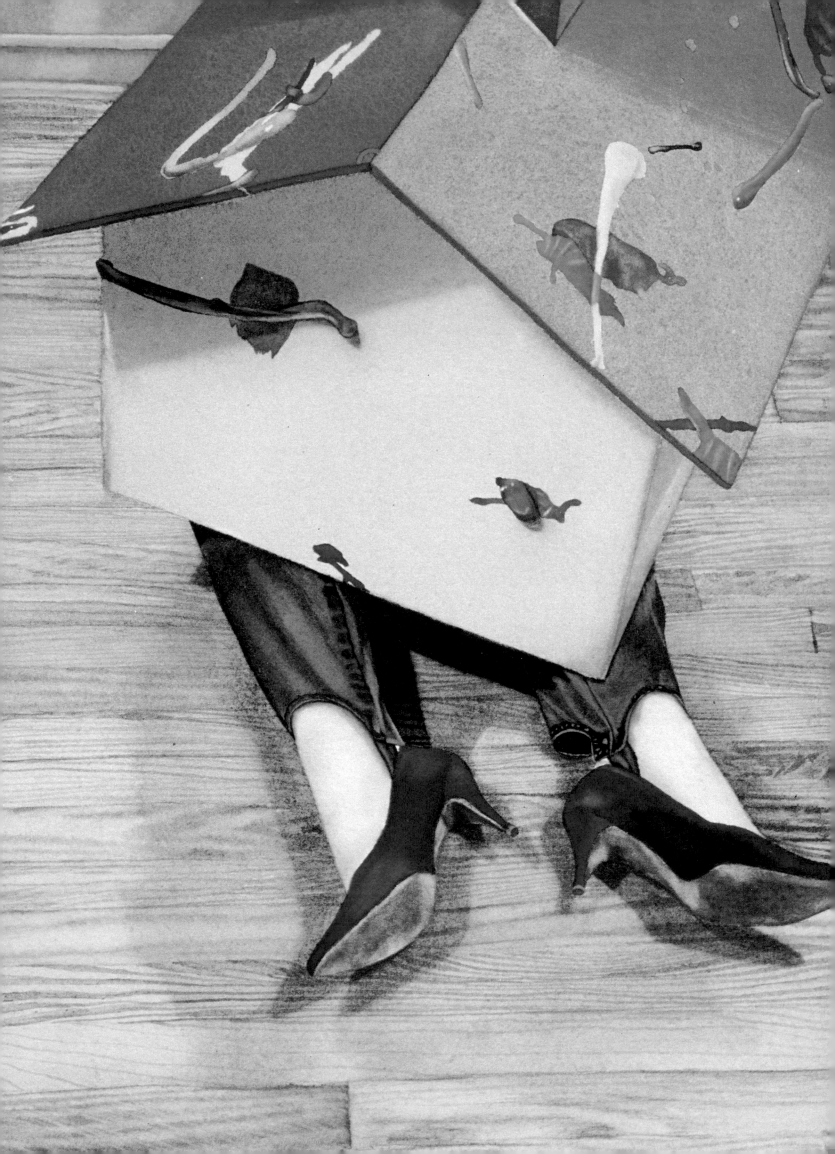

CONCEPT

A work of art begins with a concept. Concept can be as minimal as the desire to splash paint on paper and discover new forms and colors; or it can be as complete as assigning a specific symbolism to each object in a formal design. This diversity is what makes each painting the unique product of an individual. Some artists primarily seek to express ideas, others concentrate on evoking an emotion in the viewer, while still others see their concept in purely visual terms. The inspiration for a painting can come from outside or from within but cannot help but reflect the spirit of the artist.

"To give a body and a perfect form to one's thought. This — and only this — is to be an artist."
—Jacques-Louis David

The Occupant
Elizabeth A. Yarosz
13" x 10"

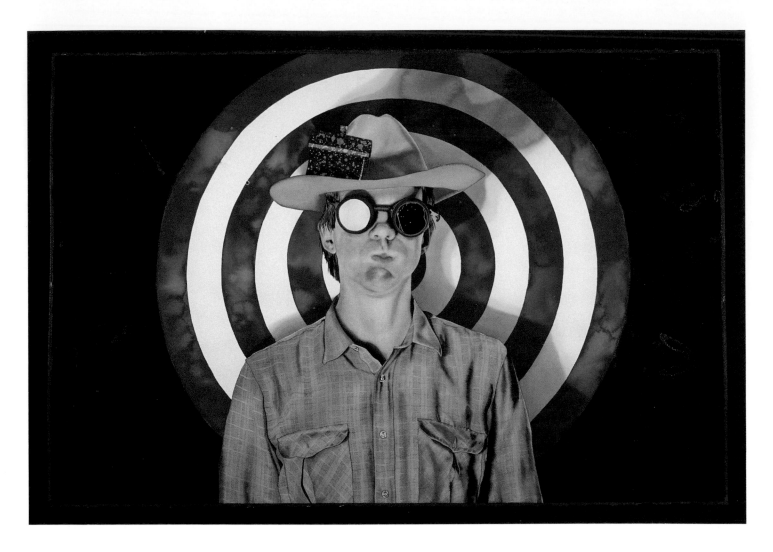

Reluctant Homesteader
Elizabeth A. Yarosz
40" x 60"

Match Symbolism with the Subject

This painting depicts a friend of the artist, a confirmed wanderer and explorer. Since returning from a trip a few years ago, he has stayed in the area, but Yarosz suspects not wholeheartedly. The portrait is formal and direct, but full of symbolism. The target and the dramatic lighting put the subject on the spot and under rather uncomfortable scrutiny.

Scale is significant as is color intensity and the contrast between the target and background; and his facial expression delivers a distinct comment on the whole situation. "There are other ideas involved and many levels of perception. I want my imagery to visually and intellectually challenge the viewer."

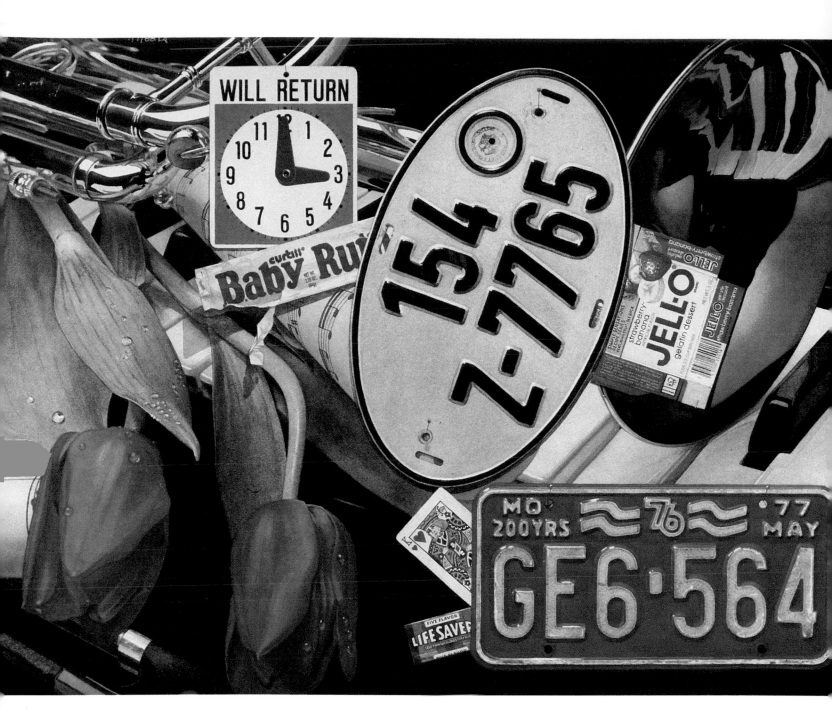

Paint a Visual Parable

Each of Addison's watercolors is a visual parable illustrating a spiritual truth. The objects are selected because he sees them as potent symbols of these truths. This painting proclaims the promise of the second coming of Jesus. The shopkeeper's door sets the theme with the words "will return" and the clock face reminds us there is an appointed time for this event—at the last trumpet blast. The King of Hearts is a symbol for God's gift of love in Jesus.

Still Life #1119
Kent Addison
22" x 30"

Sacred Spaces
Mary Beam
40" x 60"

Construct Patterns

This painting was part of a series about man's responses to the modern technical age. The artist's husband was working on printed circuit boards and their design and construction intrigued her as an artist. She wanted to use the concept in a painting about how we as humans construct patterns for our lives. The crimson color was used to make the piece dynamic, as well as playful. The lines dart back and forth like neon lights or hot circuits. Beam needed to select a symbol to be a resting point for the eye, so she chose the apple for its simplicity and ancient symbolism. "To me life is sacred," she says, "and I wanted to show the viewer that stripped to its simplest forms it is still enjoyable and mysterious."

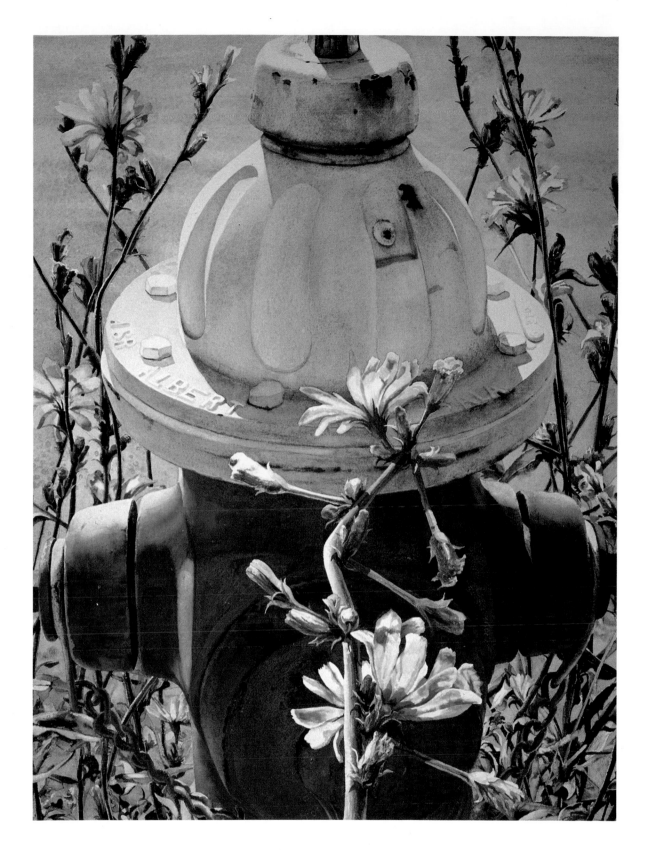

Celebrate the Commonplace

Mary Lou Ferbert finds her subject matter in Cleveland's "flats," the highly industrialized valley of the Cuyahoga River. As the American economy moves away from an industrial base to a service base, such areas as Cleveland's flats undergo a gradual decay. She is fascinated with the juxtaposition of commonplace objects with the ubiquitous wildflowers that thrive in the urban environment.

Both fireplugs and "weeds" are often completely overlooked, and yet for her, they represent something both vital and worthwhile. The hydrant has almost life-giving connotations for her: "We are on a water planet and fireplugs are dispensers of that vital resource." And the wild plants are "icons of courage, symbolizing the renewing power of nature."

By having "chicory embrace a fireplug," she creates a visual dialogue between the world of nature and the world of humankind.

Chicory and Fireplug
Mary Lou Ferbert
34" x 26½"

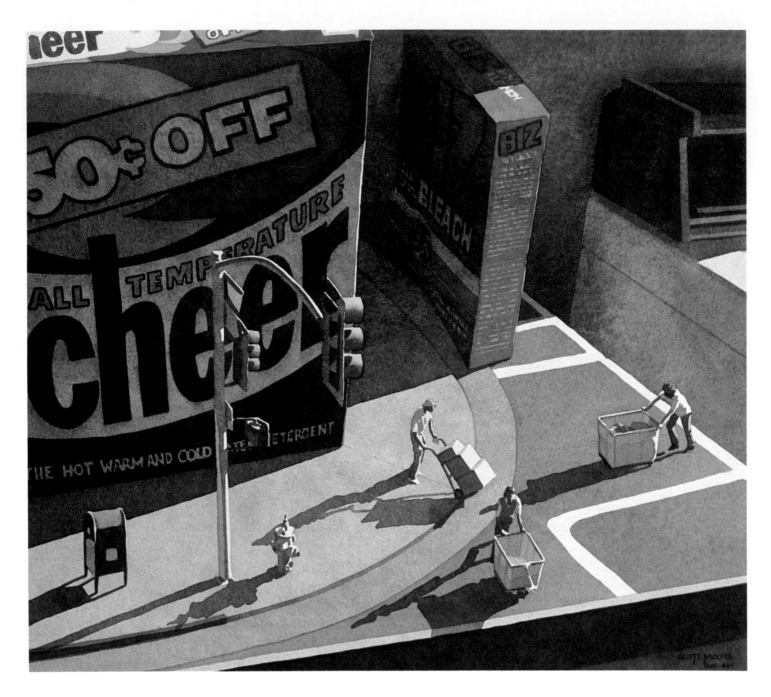

*Cleaning Up the
Garment District*
Scott Moore
18" x 18"

Explore Whimsical Images

Years ago, Moore painted a watercolor of a deserted street from a fifth story studio space in the heart of the Los Angeles garment district. As he worked his way into the watercolor, ideas kept popping into his head. What if the buildings were replaced by objects that didn't make sense? What if they were out of context, but somehow did make sense? He put those ideas on the back burner and four years later looked at a slide of that painting and transformed Los Angeles into a laundry room, replacing the buildings with soap boxes. So *Cleaning Up the Garment District* came about by looking at an old painting and visualizing it in a new way. Moore says, "Some of my whimsical paintings begin with a catch phrase or a pun, while others start with the objects themselves. A trip to the kitchen to peek in the cabinets, or a glance in the refrigerator, sparks my appetite for new work."

Painting Your Life Experiences

The title of this painting is derived from *mater*, meaning "mother," or "that within or from which something originates." Pierce did a series of paintings using clothing patterns—which grow, develop, and give form—as a metaphor for motherhood. When her five children were little, she sewed for them, and was always attracted to the shape, crispness, and translucency of the patterns. The arrangement of the pattern pieces was a creative process in itself. She composes her set-up as a puzzle, or even a confusion or mystery for the viewer. Pierce finds that she gets many, varied responses to this painting. Some see a road map, others a statement about littering. She developed the background fabric from natural sources, in this case wild grapevines and blackberries, which gives "Mother Nature" a part in her painting as well.

Matrices
Ann T. Pierce
21" x 29"

Relive a More Imaginative Time

Maczko's painting transports the viewer to a more innocent time and place where fantasy takes precedence over mundane reality, and both are integrated in a natural, magical process. Her scenes of childhood begin in her imagination. The toys and furniture she chooses for her paintings are not contemporary objects, rather they are items brought forth from her own childhood of the fifties and sixties. After sketching an idea, she begins her hunt for just the right props for the still life, scouring flea markets and thrift stores. This process alone can take several weeks. She sets up the scene in her studio and examines it carefully. When she is fully satisfied with every detail, she works directly from life.

The Mind at Play #9
Sharon Maczko
23" x 37"

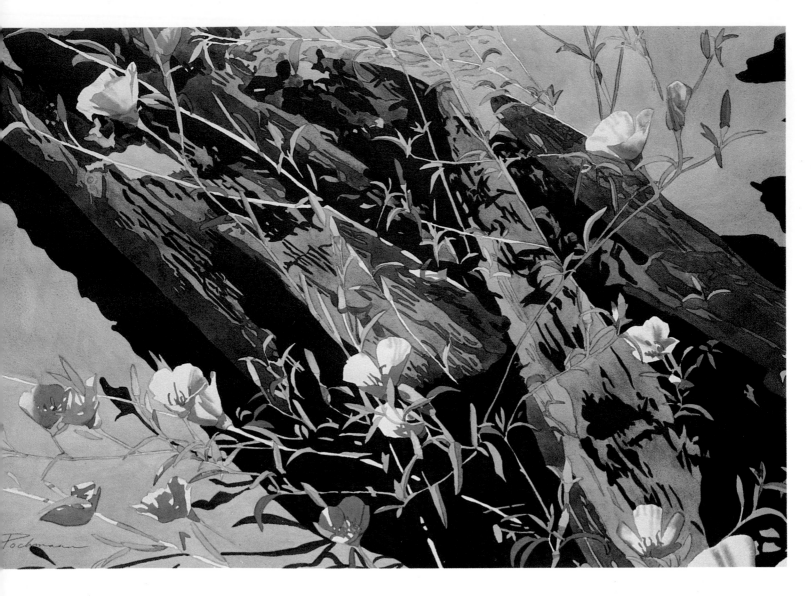

Wildflowers
Virginia Pochmann
22" x 30"

Paint a Personal Statement

"I am first and foremost in this life a naturalist, interested in life forms and their processes," says Pochmann. As she developed as a watercolorist, she painted many different types of subject matter, but didn't feel that much of it said anything about herself. Then a statement by Millard Sheets, made years ago, helped her understand what was missing. Sheets said that it is not enough to learn *how* to paint, but it is necessary to find out what it is you have to *say* about the world in which you live, and then find a way to express it in paint. Pochmann feels it is important to be aware of the endless beauty in nature all around us. She enlarges her subjects to emphasize the importance of the small things. Recently, her work has changed some in direction. For years she concentrated on a single enlarged blossom or animal. She now places the organisms within their microenvironments as seen in *Wildflowers*.

Use Your Emotions as a Source

"My work is a conversation with myself," Lynne Yancha says. "My point of view in regard to my paintings of solitary children seems to be one of quiet peacefulness. But, at the same time, my awareness today is that pain fuels my work. My work expresses or tries to understand the hurt, lonely child within, as well as the pains and joys of parenting. What you see in *A Shared Space* is the positive side of that struggle; the peace that I feel in solitude which leaves me with a tangible sigh of serenity."

A Shared Space
Lynne Yancha
15" x 20"

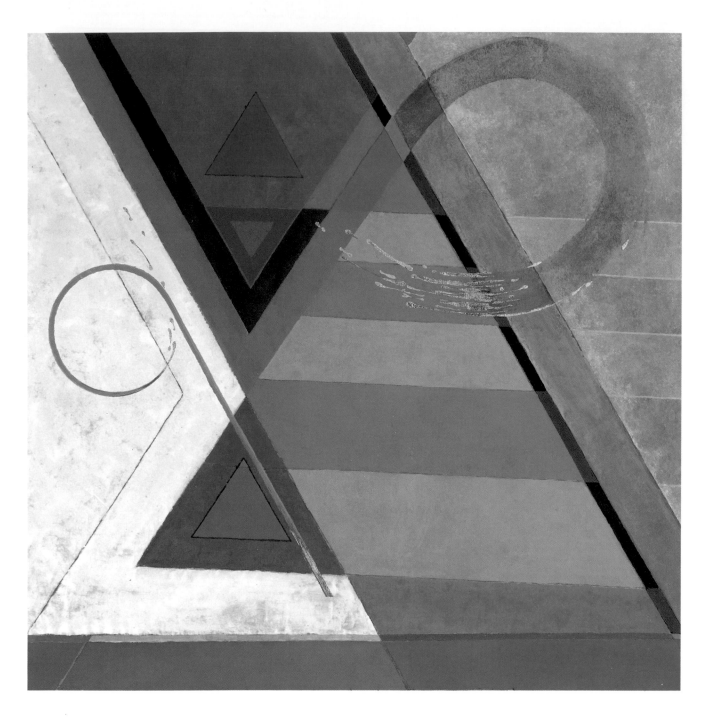

Signet I
Glenn R. Bradshaw
24" x 24"

Expressing Your Concept in Abstract Images

This is a casein watercolor on Sekishu white paper with some gold leaf. Bradshaw builds his paintings improvisationally, adding color to both sides of the paper. The form and title of this painting might suggest that it is a symbol for an idea, but the artist's concept in this case is strictly one of image and design. "Conceptually my work has moved from on-site representational work to studio invented nonobjective painting," says Bradshaw. "The land and waterscape of the north woods figured heavily in my subject matter for many years and the relationship between enduring elements and the immediate, such as wave against rock, has been a recurring theme in much of what I have done. This balance between the fixed and the fluid, the geometric and the gestural continues to be seen in my current paintings. My paintings are orderly. Divergent elements are orchestrated so that the most impulsive splash is harmonious with the most calculated mark. Color contributes strongly to the mood of each work and I intend each work to have a visual richness and character that takes it beyond just design. It is lyrical. It is intended to be art that is enjoyed visually without other reference."

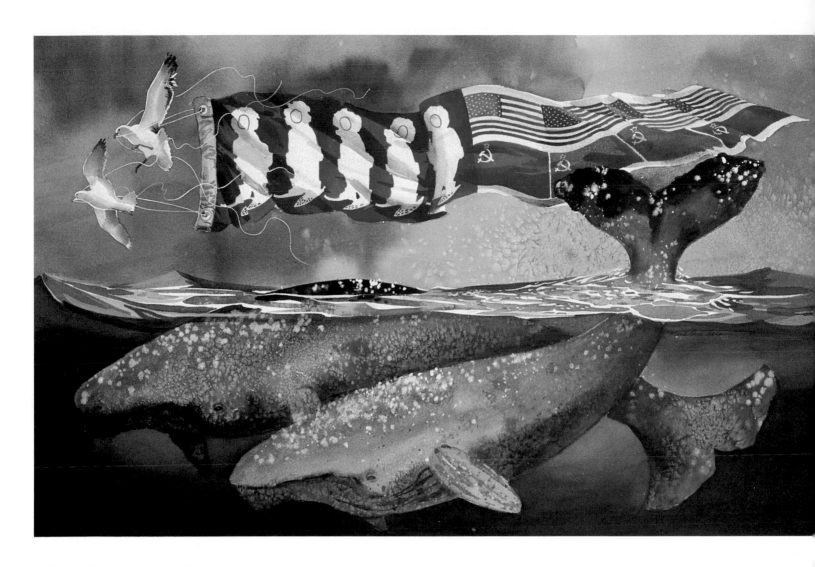

Find Ideas in Current Events

The idea for this painting came to Mary Ann Chater after she read news stories of the many people who had helped free several whales trapped by ice in Alaska. Since much of her work deals with the interaction between man and animals, an interaction that doesn't always benefit the animals, she felt a strong positive response to this concern for the whales. Her painting, *With a Little Help from Our Friends,* celebrates the situation's successful resolution.

Chater used a cool palette to suggest the icy northern location, even choosing alizarin crimson because it is one of the coolest of reds. The sea gull messengers, bearing the banner with symbols of those who helped, represent freedom of movement as they fly above the liberated whales.

With a Little Help from
Our Friends
Mary Ann Chater
25" x 40"

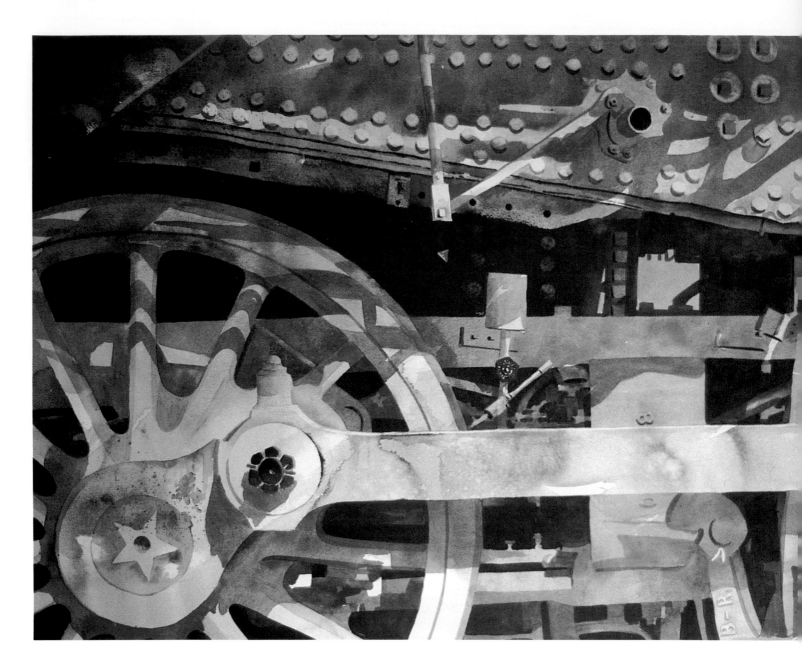

Wheel Series #12
Jerry Ellis
22" x 28"

Evoke the Essence of Your Subject

The subject matter of Jerry Ellis's watercolors are the giant drive wheels of old steam locomotives. These massive wheels were turned by enormous steam-driven steel rods that, to him, evoke a feeling of power and energy waiting to be unleashed. Every bolt, rivet, and rod speaks of the tremendous forces once harnessed by these great steam engines, which were not only machines of marvelous power, but also beautifully wrought creations. It is this mechanical beauty that Ellis captures so well in his close-up portraits of the locomotives. He frames their intricate mechanisms carefully to create a fascinating pattern of shapes and directions, and honestly renders the many textures of the aging metal.

Find Meaning in the Ordinary

"The content of my work for the past fifteen years can be summarized in a few words: affirmation of the sacredness of life. The appearance of strong sunlight on natural forms elicits an emotional response from the viewer—one that I believe is warm and joyous. In my paintings, the depiction of light is used not only to reveal form but also to symbolize the presence of the Creator in the created; to symbolize a spiritual force at work within the form." In this painting, the "bull's-eye" format of the composition creates what Stevens calls a unified "circle of life...interdependent and never ending."

Feather Light #7
Linda L. Stevens
29½" x 42"

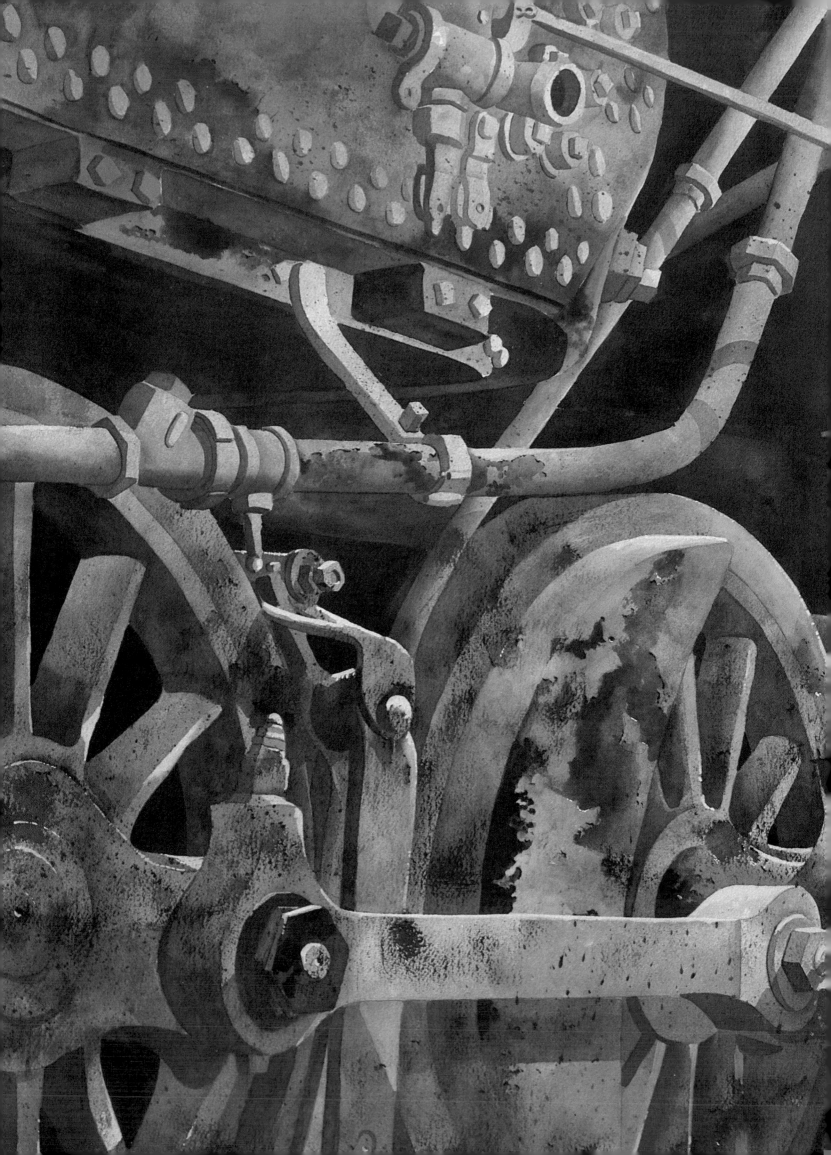

TECHNIQUE

A concept remains known only to the artist until technique is employed to make that idea visible. The remarkable versatility of watercolor is evident in the range of techniques used by the artists represented here. Dazzling results occur, not because of a "best" technique, but because the technique is in perfect harmony with the concept of the painting. The purpose of technique, no matter how simple or elaborate, is not to draw attention to itself, but to communicate the artist's message. It can be controlled or loose, traditional or accidental, but when it does its job—a painting becomes art.

"Every artist was first an amateur."
—*Ralph Waldo Emerson*

Driving Wheels #2
Jerry Ellis
30" x 22"

Environs of Pamajera #71
Alex McKibbin
29" x 40"

Make the Most of the Materials

Because McKibbin's short colorful brushstrokes do not describe so much as imply his subject matter, he can simultaneously suggest mood and atmosphere. In *Environs of Pamajera #71*, the darkness and density of his strokes create the sense of being in the cool, damp, and dark interior of a woods. He has enhanced the feeling of distance and the impenetrability of the surrounding foliage by varying the size of the strokes. Many small areas of the white paper show through, making the painting sparkle with light. The linear activity of McKibbin's brushwork characterizes his distinctive approach to watercolor. By planning areas of lesser activity carefully, the artist creates rest stops for the eye so the dynamic energy of his brushwork doesn't fatigue the eye.

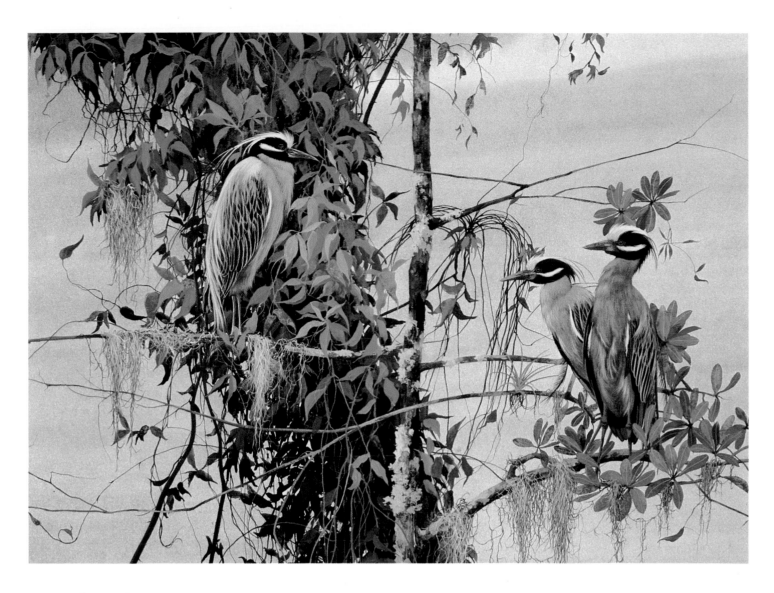

Use Acrylic on Illustration Board

Yellow Crown Night Herons
Neil H. Adamson
31½" x 23½"

Adamson is attracted to shapes he finds in the landscape, along the coastline and in wildlife. He makes himself really see his surroundings in order to remember it, feel it, and live it. He especially likes to paint the Everglades and other areas of Florida that still remain in their natural state. He paints on illustration board with a very smooth finish so surface texture will not interfere with his crisp detail. *Night Herons* was done in acrylic watercolor because subsequent washes will not lift previous colors. He likes the paint to lay on top of the paper, which he feels gives rich, strong, bright color that can still be manipulated for the look he wants. He used a soft wash for the background, and laid in a large, dark mass for the leaves, bringing out the details later.

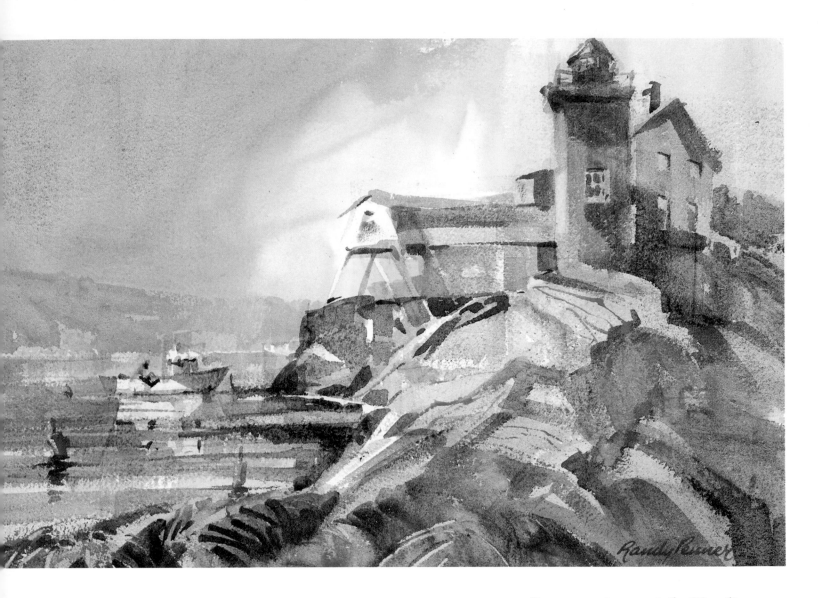

Maine Motif
Randy Penner
14" x 21"

Improvise with Tools at Hand

"I regard technique as merely a means to an end," says Penner. In *Maine Motif*, his end was to convey the ruggedness of the coast. Starting with a rough paper, he left most of his direct strokes untouched, rough edges intact. To create some of the textures, he made use of the flat plastic fob of a key chain, which just happened to be available. With this tool, he scraped and applied paint in some places. "Experimenting now and again is not only a way to avoid ruts, it is also a sure way to discovery and the resulting excitement. That is my goal—never to be complacent and content with where I am, but to pursue, as long as I am able, the potential that watercolor affords."

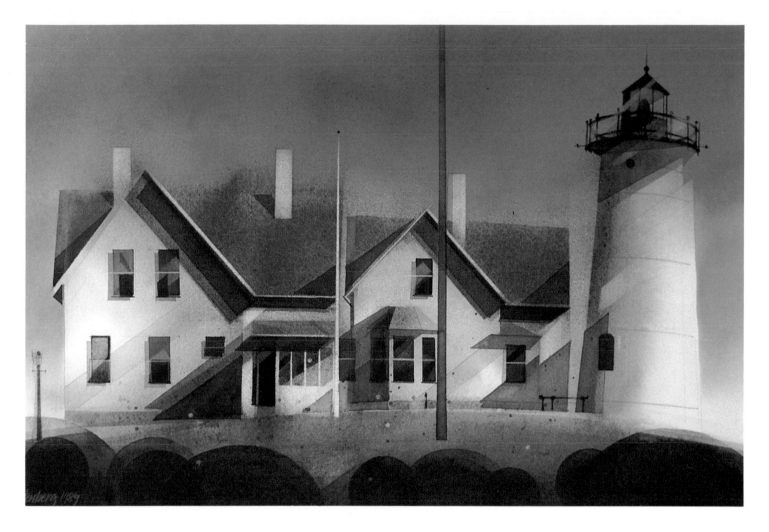

Weave Hard and Soft Edges Together

"Light interacting with structure is my stock-in-trade," says Stoltenberg. "I like the light to melt away parts of the form, make it flow as energy in and out." In *Nobska Light* there is a constant tension between the sharply defined and the soft, misty suggestion. Stoltenberg plays with the question, "How much definition can you take away from a form and still have it read clearly?" To create this

effect, he begins by soaking his paper, then dropping fluid color onto it and tilting the board, allowing the colors to intermingle. After the paper has dried, he used masks to create sharp edges and to control the sponging out of light areas. This sponging out and painting in were repeated over and over until the right relationships were established.

Nobska Light
Donald Stoltenberg
13½" x 20½"

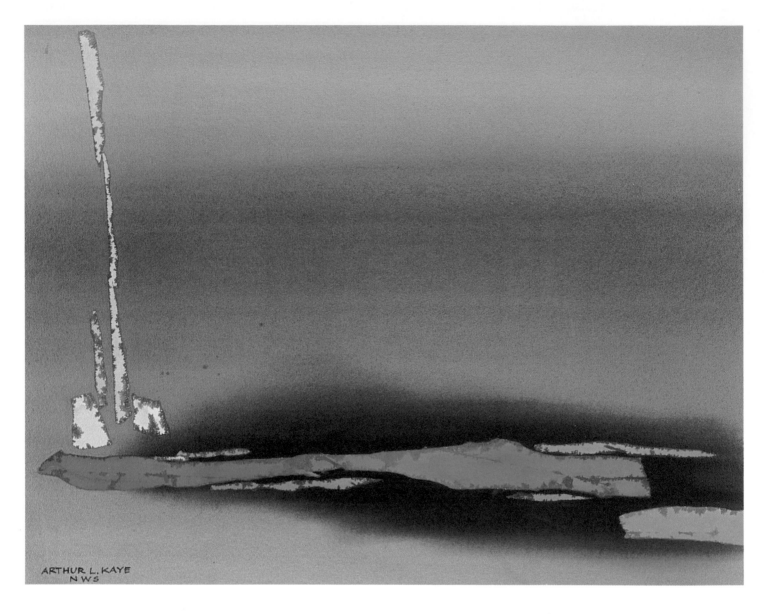

Sfumato Series VI
Arthur Kaye
28" x 22"

Plan for Attractive Accidents

For this painting, Kaye began by placing torn segments of drafting tape onto 300-pound Arches watercolor paper in an interesting arrangement, using experience and intuition. He had previously discovered, quite by chance, that if the tape was not firmly burnished down, subsequent washes would leak under some of the edges, creating attractive, subtle "accidents." Kaye applies graded or wet-in-wet background washes until a desired tonal value is established. After these dry, he removes the tape and applies more fully saturated color to the newly exposed white paper, taking care not to muddy the "accidentals." He uses acrylic washes so they are insoluble when dry.

Construct Layers with Matboard

This piece and the others in Closson's Cross series evolved from the desire to incorporate the fresh, smooth cleanness of leftover rag mat into a work of art. She began layering to give the illusion of depth, and found that cut-outs from old watercolors could be used for underlays. After developing this work, concentrating solely on design, Closson became aware that it had become, in some way, a metaphor for her relationship with God. The underlying watercolors, with all their weaving motion, represent the intertwining, growing nature of that relationship, while the white, clean, overall feeling symbolizes perfection or innocence.

Waves
Nanci Blair Closson
32" x 40"

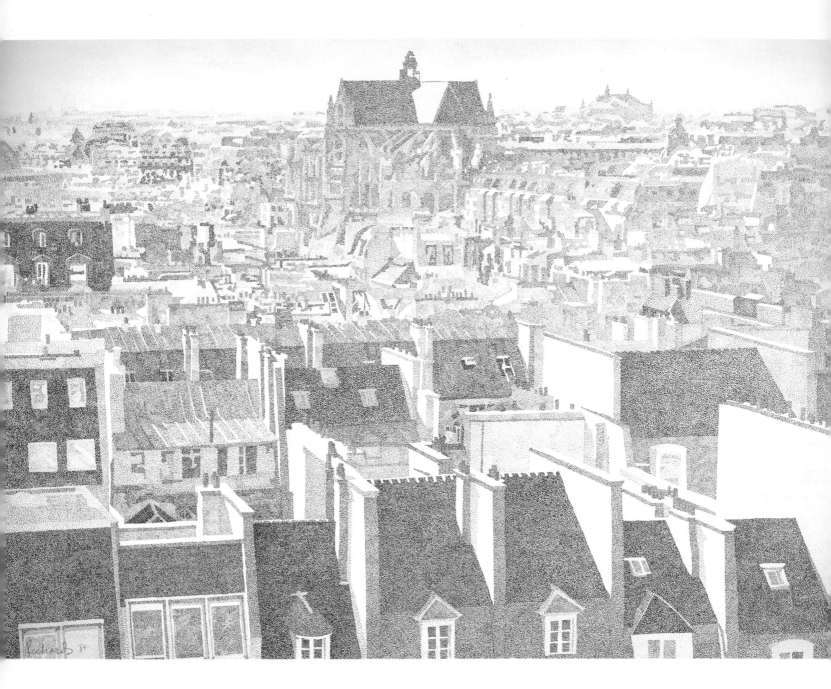

St. Gervais—St. Protais
David Richards
30⅛" x 43¼"

Use Dots of Unblended Color

This pointillistic approach of reducing objects to their smallest component, namely the dot, allows Richards to deal with unlimited subject matter while exploring their component colors. The transparency of watercolor juxtaposed with the white space between the dots provides an ethereal effect, creating an idealized representation of the beauty of nature. Here, the artist developed color interest by using a different combination of colored dots in each contiguous plane in the painting, and left areas of unpainted white paper weaving through the composition to enhance the flat design. The use of aerial perspective and intricate angles sweeps the viewer freely across the painting with no single area being so focal as to arrest the movement. The soft, romantic haze in a calm monochromatic blue scheme presents an image that is both beautiful and tranquil, as the artist intended.

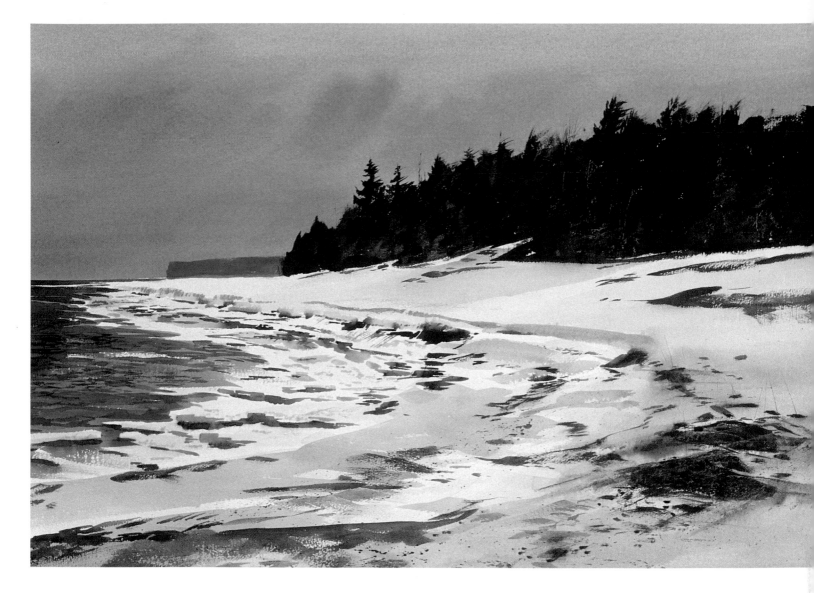

Simplicity Can Say It Best

Johansen wanted to capture the brilliant quality of the winter light on this snow-covered shoreline. The success of the painting in this regard is largely due to the simplicity of design and economy of technique. There are no unusual tricks—just a strong composition based on three main shapes and tonal values, and an elegant use of the transparent medium, offsetting the bright white of the paper.

Winter Light
Robert Johansen
20" x 27"

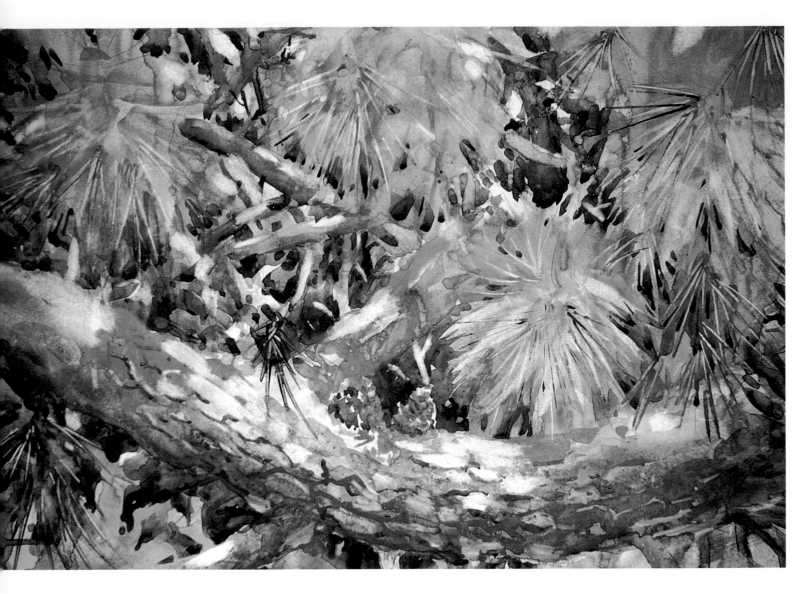

*Light through the Pine
Boughs*
Don O'Neill
21" x 29"

Coat the Paper with Clear Acrylic

In this painting, O'Neill plays with light bouncing from three directions: an almost orange light emanating from the fallen pine needles on the ground, the light reflecting from the deep blue of the sky, and the yellow-green light filtering through the pine needles themselves. The multi-directional light and the complexity of the subject itself was an interesting problem for the artist. His solution was to apply a clear acrylic coating to his stretched paper, which enabled him to scrape or wipe out pine needle shapes or retrieve a lost light at any time. Many areas were constantly wiped out and redone so they did not "say it all" by being too realistic.

Layering with Acetate

Sometimes a new material will open a whole new world for the artist to explore. San Soucie was introduced to prepared acetate and began using it so she could paint on a completely transparent surface. The paint adheres well with no beading or flaking. She uses the prepared acetate to create richly layered abstract images, combining transparent watercolor with the transparent acetate. Each subsequent superimposed layer allows the colors below to modify and enliven the colors above. Layering with acetate also captures shadows of the uppermost layers, giving a unique sense of pictorial depth to the painting, an effect the artist enhances by placing thin sheets of Plexiglas between each painted layer. San Soucie uses layers of rows of repetitive strokes, originally inspired by grasses and weeds, to create an eye-catching rhythm that animates her paintings.

Aquarelle avec les Papiers
Pat San Soucie
19" x 24"

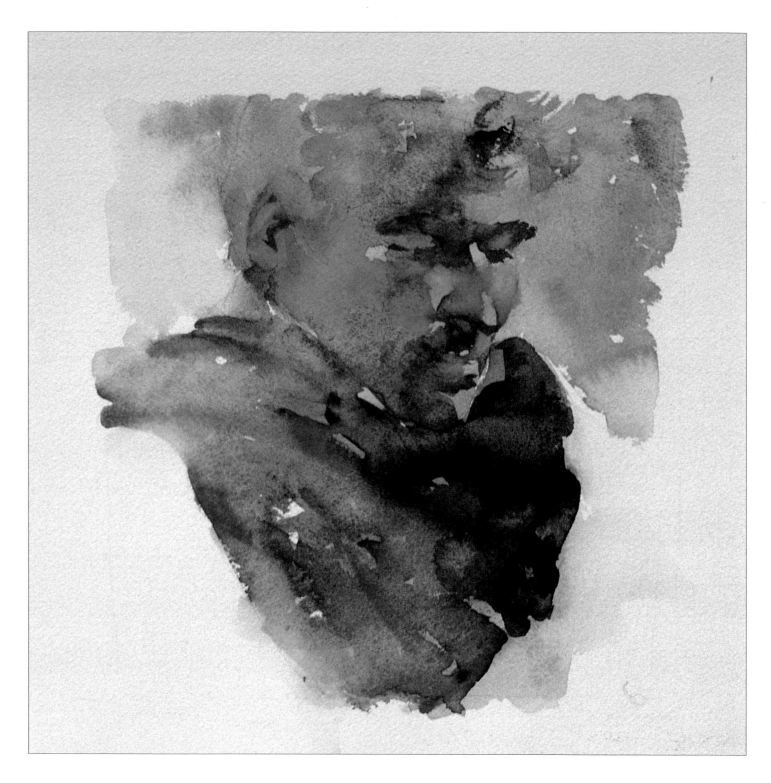

Meditation
Roberta Carter Clark
11" x 11"

Keep It Simple

Sometimes the best technique is the simplest. Here, Clark wanted to portray the idea of a person immersed in serious thought. The painting is small and intimate and was done with direct, transparent strokes and a minimum of drawing. Subdued color was applied directly and allowed to blend on the paper. The lack of detail in the face allows the viewer to identify with the subject and participate in the introspective mood. Some of the edges are lost, which permits the viewer's eye to roam through the image.

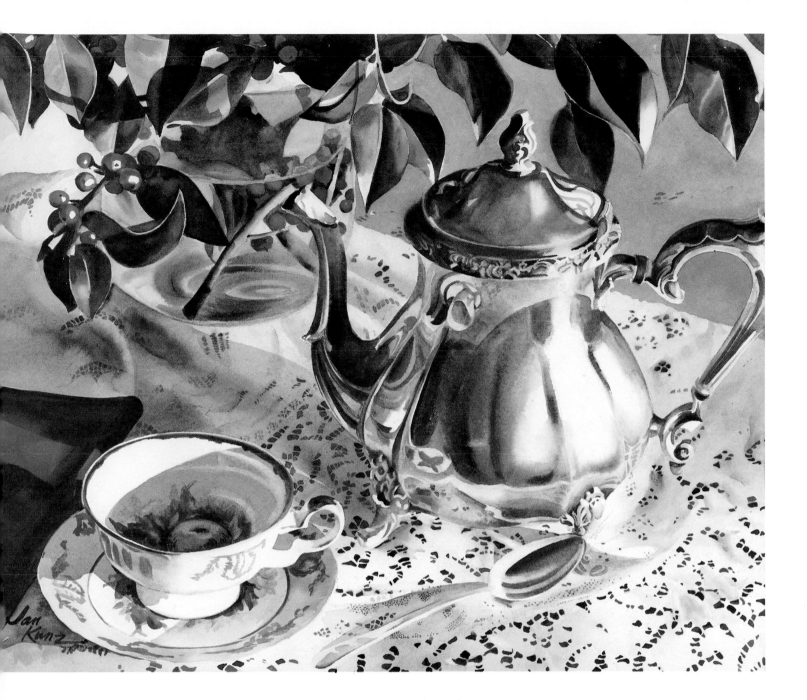

Use Clear Water to Achieve Soft or Hard Edges

Christmas Coffee
Jan Kunz
22" x 30"

This watercolor contains a remarkable variety of textures and surfaces: polished, highly reflective metal; lacy fabric; smooth, hard porcelain; and soft leaves and petals. The artist achieves these textures by a careful application of color using two basic techniques. First, she uses a wet-in-wet technique, allowing the paint to mix and blend on the watercolor paper rather than on the palette. Second, she builds up color by applying layers of paint until she achieves the value and texture she wants. The secret to the success of both techniques is using clear water to wet the paper in specific places to control the softness and hardness of the edges.

Dream Series Evanescent
Joan Ashley Rothermel
25" x 40"

Combine Transparent and Opaque Colors

"I suppose what is most gratifying to me is the continual sense of discovery in the painting process, which is one of change and adaptation," Rothermel says. "This work was not preconceived; the final shapes and colors evolved as the process of laying down colors in various ways proceeded. The techniques consisted of brush painting, then outlining some forms, then masking off areas in geometric sections for airbrushing. The airbrush was used because the profusion of organic shapes needed to be tempered by straight edges. Transparent and opaque paints were played off each other for some of the effects. The artist says, "I cannot think of any way in which this effect could have been achieved through the use of transparent watercolor alone." These effects add to an enigmatic air Rothermel likes to project in her paintings. "For this reason, many of the shapes and larger passages in my paintings are purposefully indecipherable."

Explore New Ways to Lift Color

Fossil Field
Michael Schlicting
22" x 30"

Over the past few years, Schlicting has been doing a series dealing with rock strata along the beaches and headlands. In order to make his paintings feel "geological" he has developed several techniques. To "lift" many of the fossil and rock shapes, he has found that an airbrush with clear water and lots of pressure removes most of the pigment without damage to the paper. He also cuts Mylar templates to isolate areas of the painting for lifting with a damp sponge. In *Fossil Field* he explored the possibility of incorporating extensive use of gouache into the transparent water-color. The rich textural development and bold colors keep the viewer's interest and convey a strong design whether seen from six inches or from across the room.

COMPOSITION

Composition is the loom on which a picture is woven. Without structure, the threads of ideas and technique would fall apart. The raw materials such as color, line, and shape need to be carefully placed and interwoven. The whole must take precedence over any one part in a successful work of art. It is by the deft weaving together of these separate strands that the artist determines the way a painting will be seen: the path the eye will follow, the areas to be lingered over or passed through quickly, the places that speak the loudest. It is the quality of the weave, rather than the beauty of each individual fiber, that makes the "fabric" of a fine painting.

*"Design is like gravity—
the force that holds it all
together."*

—E. A. Whitney

Two Aquariums
Nanci Blair Closson
30" x 22"

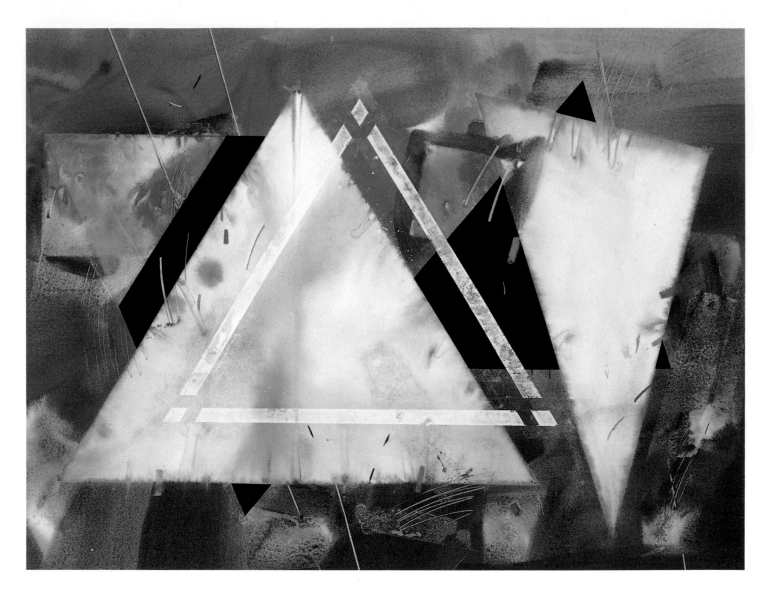

Diversion
Evani Lupinek
22" x 30"

Create Tension with Design

Tension created by contrast is the driving force in the composition of this painting by Evani Lupinek. It contains a whole series of oppositions: A loose painterly application of paint is set against strict, precise triangular forms. A sense of three-dimensional space is balanced by flat shapes. A stable pyramidal form is confronted with a triangle precariously placed on end. Soft amorphous shapes are pitted against hard geometry. Light shapes are set off by dark.

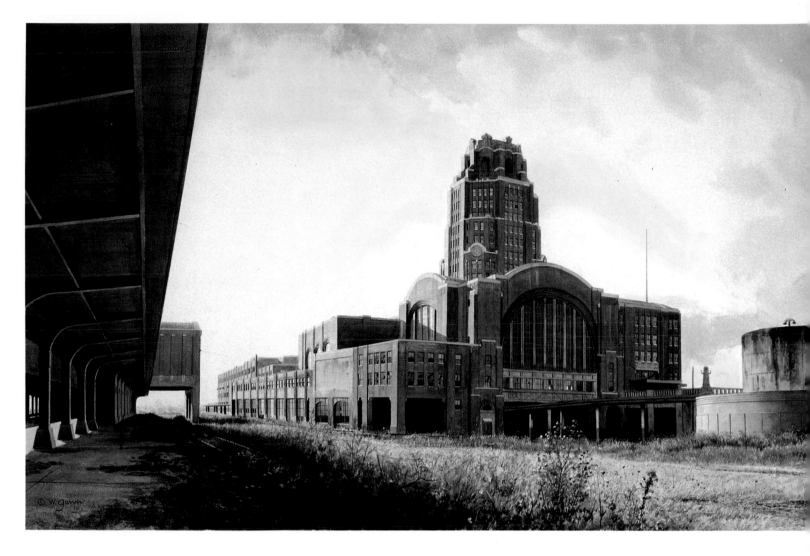

Dramatize Light and Perspective

The abandoned and decaying monuments of America's heavy industry have attracted many artists. Perhaps the attraction is the feeling of lost grandeur or the inexorable progression of time suggested by ruins, be they the fallen columns of ancient Greece or the deserted factories that dot our landscape.

Walter Garver found a lingering sense of energy present at this Art Deco railway station worthy of capturing in watercolor. He chose this particular view because the direction of light created a strong, dramatic pattern of lights and darks. The dramatic perspective emphasizes both the scale and the desolation of the scene.

End of the Line
Walter Garver
22" x 24"

Brownstone Gourmet
Arne Lindmark
22" x 30"

Improve upon What You See

Lindmark is entranced by the changing of shapes in nature and how the eye is attracted by changes in value and color. But rather than copying what he sees, ninety percent of his work involves black-and-white value sketches, moving and distorting shapes to create a better design. He says, "Light in my work is only used to create shapes and stage them. If I can do nothing to enhance the subject at hand, I will not paint it." In

Brownstone Gourmet, the strong horizontal of the canopy is offset by the verticals of the building and the light pole that is the center of interest. Lindmark intends for the viewer's eye to wander through the various changing shapes staged most strongly in a loose *S* shape around the pole. "My most important statement is: If nature gives you a perfect composition, leave it for the photographer."

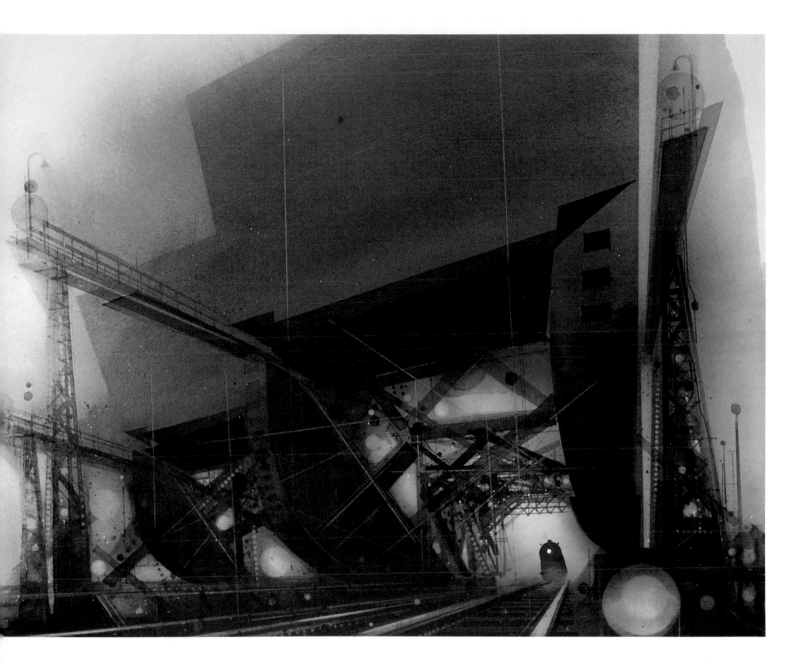

Draw the Viewer into the Painting

The ponderous sculptural character of the two railroad bridges and the spatial excitement of the tunnel-like opening attracted Stoltenberg to this subject. As a compositional device, this simple arch draws the viewer into the deepest point of the painting, the headlight of the locomotive. But to prevent the eye from getting there too quickly or staying there too long, a series of counter directions, details, and competing secondary centers of interest were set up, such as the almost lacy patterns of the trusses. Looking up at the subject gives it a monumental quality that raises it out of the ordinary. Stoltenberg says, "The aim is to attract the viewer initially with a dramatic and bold composition and then hold attention with subtleties and ambiguities only seen with longer observation."

Headlight
Donald Stoltenberg
21½ " x 27"

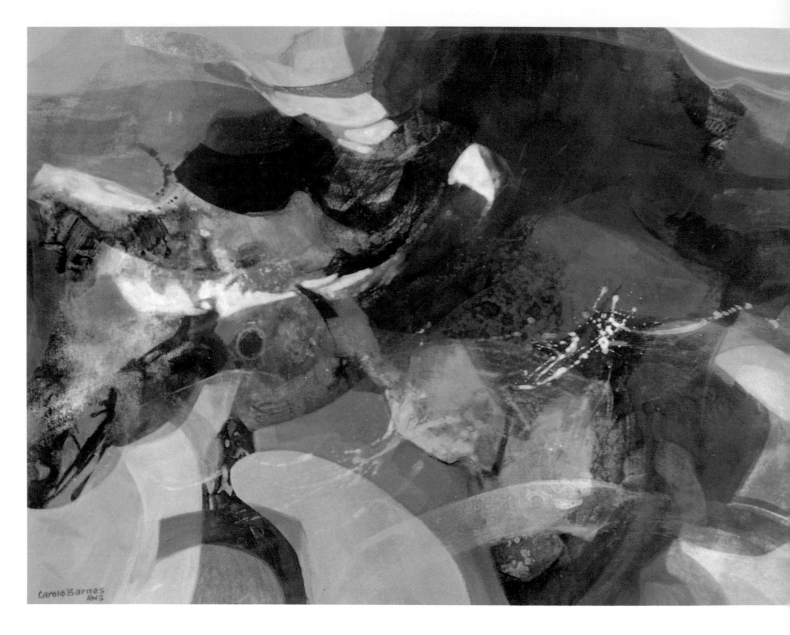

Ocean Dreaming
Carole Barnes
21" x 26"

Compose with Rhythm and Movement

Ocean Dreaming was completed at the beach in South Carolina. It was based on feelings from a successful workshop the artist had just taught; feelings she likens to the ebb and flow of the ocean. She wanted the composition to express these feelings and the essence of the ocean, which she sees as strength with many layers under the surface. "Energy is shown by the jewels of unexpected color," Barnes says of the painting. "An open area at the top suggests change, spirit, and movement. The upper right area of my painting pulls your eye in a flowing, smooth way. The strength of the bottom area invites you to 'take the trip again.' Rhythm and movement are important to me in my work."

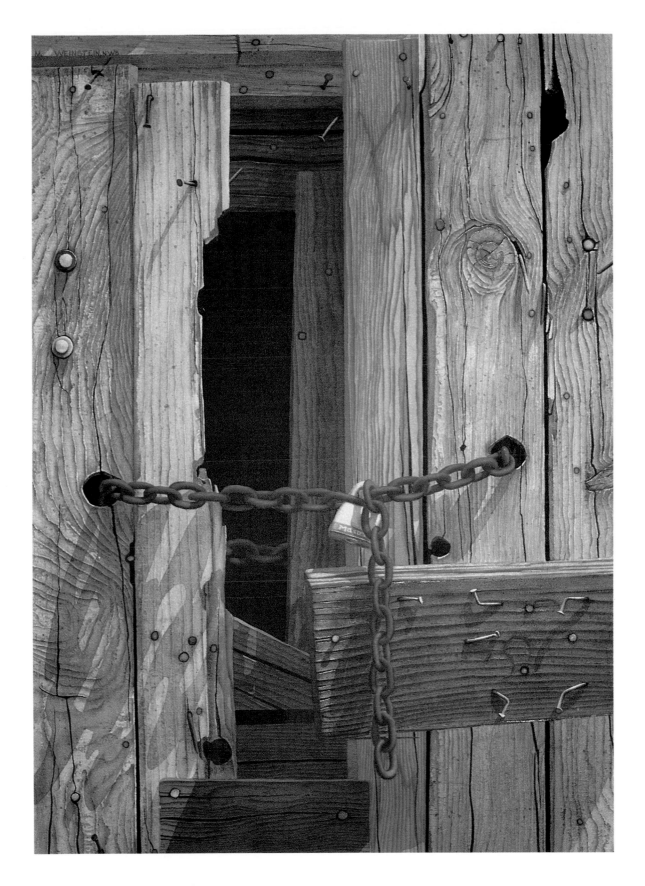

Use Variety and Repetition

The principles of composition apply to realistic painting as well as to abstract work. Although *Wood Door Series #12* is a very realistically rendered image, the composition is essentially abstract. In other words, the composition "works" without reference to the subject matter.

Variety and repetition are two compositional principles in effect here. Notice the subtle variety of colors and textures. No two boards are alike. As the eye scans the painting, it is constantly offered visually interesting edges and patterns.

Wood Door Series #12
Mary Weinstein
30" x 40"

Desert Echoes
Arthur Kaye
22½" x 17½"

Variations on a Theme

"My primary intent at the outset was to create a balanced composition using my usual method of applying torn pieces of drafting tape to mask off areas of the paper," Kaye says of *Desert Echoes*. Two opposing forces are used to create a vibrant balance. The artist was careful to arrange the horizontal forms so the heavier unit, lower in the painting, established a sense of stability. Their similarity both in color and shape, along with the opposition of their direction, sets up a tension that sustains the viewer's interest. At the extremes of the horizontals, smaller forms prevent the viewer's eye from exiting the frame. The hard edge of the earth-toned shapes is played off the soft gray of the wash. *Desert Echoes* was titled following its completion when Kaye realized that the earth tones evoked images reminiscent of the Southwest.

Entertain the Eye with Contrasts

Contrast is one of the most important principles of design for the watercolorist. In this painting by Tony Couch, notice how the artist uses contrast to attract the viewer's attention and then entertain him as he scans the painting. Tony has used contrasting values, colors, textures, and shapes to make every part of his painting interesting. He establishes a strong center of interest by placing the darkest values against the lightest values in the natural focal points of the rectangle. The natural focal points are found off to the side and up or down from the true geometric center. In this painting, the sunlit rock, center left, and the fallen tree, center right, act as magnets for the eye due to the great contrast of light and dark at these points. Throughout the painting the artist has contrasted warm colors against cool colors, soft edges against hard, rough textures against smooth. Wherever the viewer looks, something is going on, which keeps the viewer interested, and his attention focused on the painting.

Spring Thaw
Tony Couch
22" x 30"

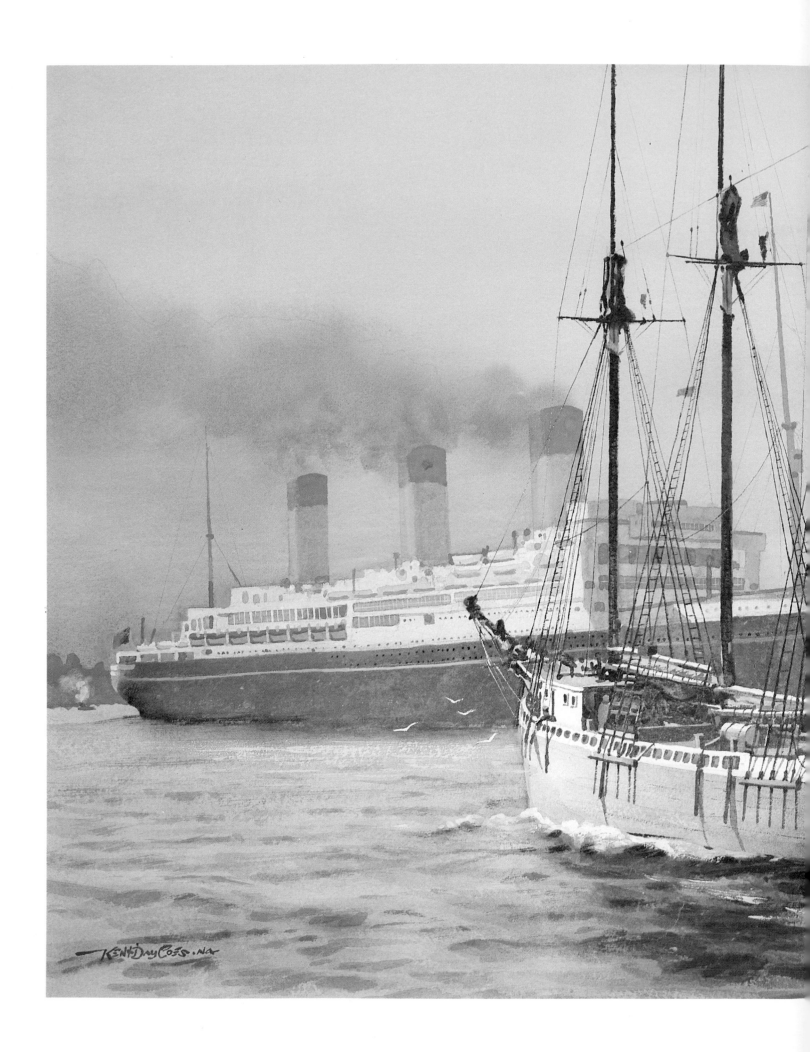

Revive Old Photos with Memory and Imagination

"A long time ago, when I was attending art school in New York, I went back and forth from my home in New Jersey on the ferries across the Hudson River," Coes recalls. "This was in the days of the big transatlantic steamships, and I saw them frequently steaming in and out of the harbor. I began carrying a pocket camera to record the impressive sight. The resulting prints were so unimpressive that I stuffed them all into a drawer with their negatives. World War II came along; the big ships passed into limbo. Forty years went by before I came across the little hoard of photos tucked away in a trunk.

"My wife suggested the possibility of using them for paintings. I got the best professional enlargements I could obtain. The compositions that finally emerged in the paintings were combinations of two or more photos; color came from memory and imagination. The title of this painting was taken from Robert Louis Stevenson's epitaph on his grave in the Samoan Islands: 'Home is the sailor, home from the sea.' "

Home from the Sea
Kent Day Coes
21" x 29"

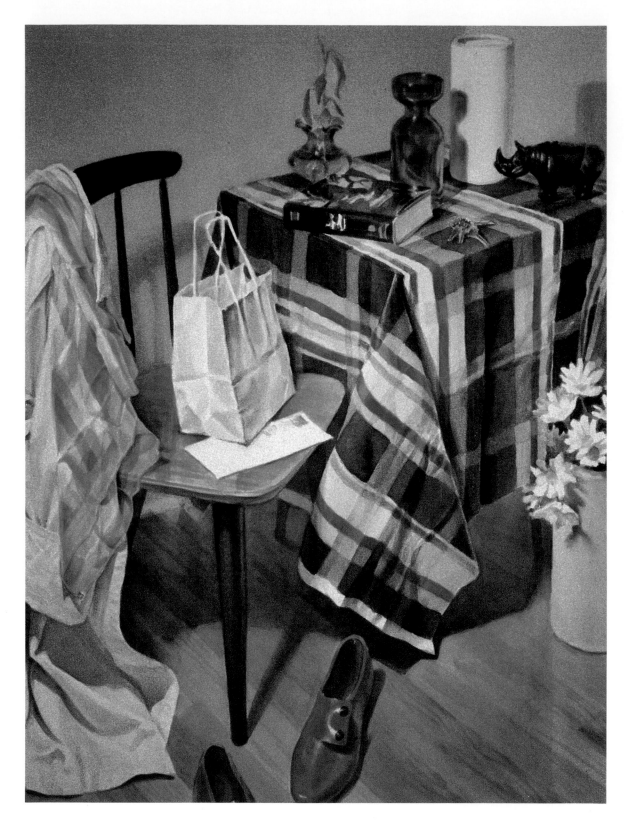

Rhino
Priscilla Taylor Rosenberger
30" x 22"

Tell a Story with Composition

Composition has two aspects, a visual aspect and a psychological aspect. The visual aspect refers to the way the artist uses line, color, shape, and all the other elements of design to lead the viewer's attention through the picture. The psychological aspect refers to the way a composition "tells a story or communicates a mood." In *Rhino*, the artist has blended the two perfectly. The eye is guided through the painting as it assembles the "story." The story begins on the left, coat and shoes off, letter and bag down, keys thrown on the table, next to the familiar and comfortable objects of home. The painting suggests the unseen presence of a person who has just returned home after running errands on a rainy day.

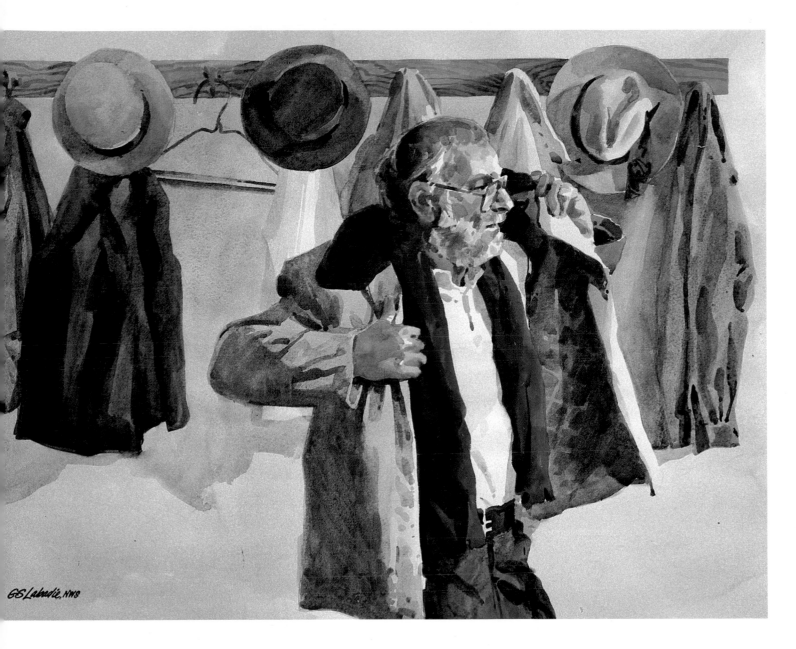

GSLabadie, NWS

Depict Movement

George Labadie's painting, *Jonathan*, is about movement. The artist believes that most paintings are a slice out of time, or a "segment in the life of a subject where all movement is momentarily suspended." In this instance, horizontal movement was suggested by the repetition of the vertical forms of hats and coats hung in a coatroom, like a freeze-frame image. The single light source on the right directs the attention from left to right and back. By making the figure larger and by adding color and texture, the artist created a focal point. Movement is temporarily halted, then resumed by the man's horizontal arm. The horizontal coat rack stops short of the right margin, preventing the eye from following right out of the picture!

Jonathan
George Labadie
22" x 30"

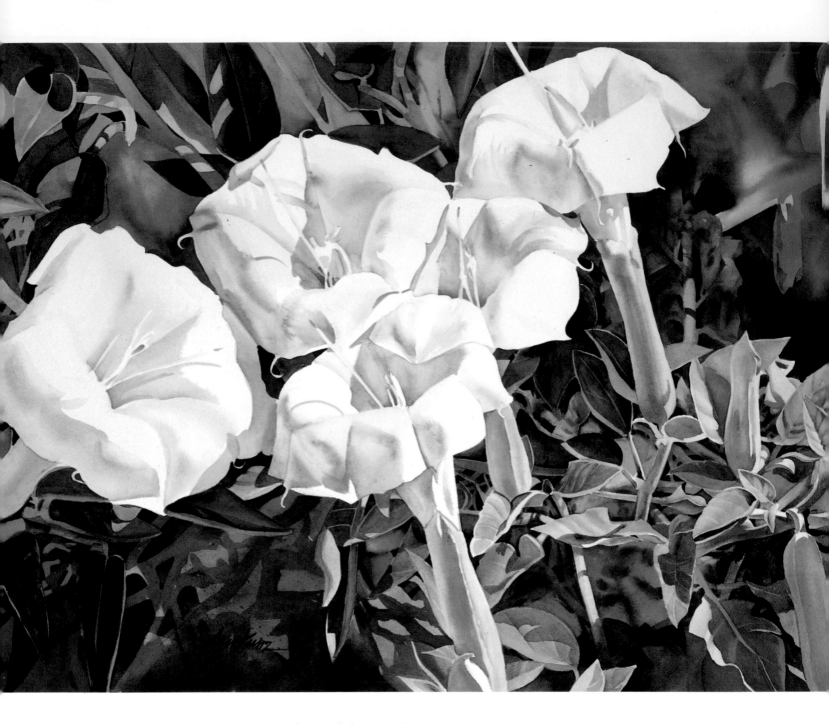

White Glory
Jan Kunz
22" x 30"

Let One Shape Dominate

The power of this watercolor by Jan Kunz is produced by contrasting the strong white shapes of the flowers against the background. Since all the flowers touch, they form one dominant large shape. The artist makes this shape interesting by varying the dimensions of the negative shapes around it. Inside the white shape of the flowers are delicate washes of warm and cool colors, which impart the glow of sunlight to the petals. The background is enlivened by pitting the cool, precise rendering of the leaves and stems against the warm, soft ren-

dering of the soil below. Notice how Kunz paints negative shapes to suggest the more distant background foliage. Even though the background is full of interesting shapes, textures, and contrasts, it still serves as a foil to the flowers. Kunz says her background in commercial art has helped her appreciate the importance of presenting only one message at a time in a composition. "The challenge now is to further simplify my paintings by learning to say more by saying less."

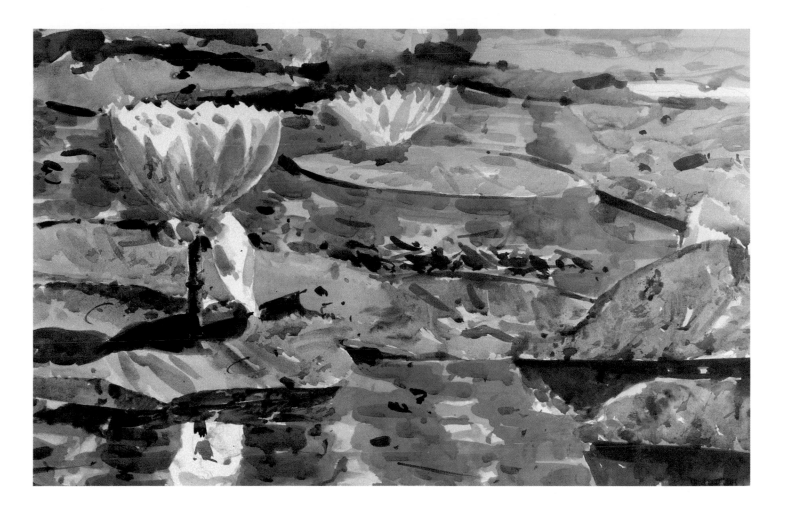

Be Bold and Spontaneous

"Simplicity is first and foremost," Knott says of her paintings. "My strongest compositions are essentially simple." After loosely drawing the interesting shapes and forms of the lilies and lily pads in this painting, Knott intuitively worked out the pattern of light and dark by building up layers with bold spontaneous strokes. As she developed the painting, she continually worked the entire surface so the elements would hold together. A limited palette also serves to unify the composition. The eye progresses through the painting by jumping from one lily pad to the next. The lilies are given prominence by their simplicity of form, their light value, and their placement in the picture.

Lily
Dee Knott
32" x 40"

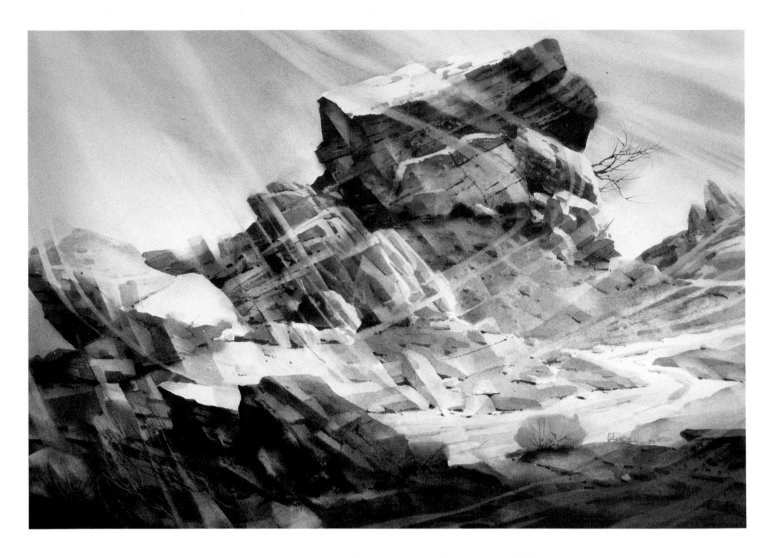

Windswept Mountain
Carl Purcell
22" x 28"

Break Down the Boundaries of Form

To Purcell, this painting is a celebration of life and life forces. He sees landscape forms as being in an active, living relationship with their environment. To reveal this, he sets up a story told in patterns. Light shapes set against dark change to dark against light in the alternating patterns. The composition is based on strong diagonals, with the dark shadow area at the bottom providing a solid base. The shadow area lifts as it approaches the left-hand side to meet the strong diagonal of the rock forms. The sweeping diagonals in the sky counter this movement and re-direct the viewer's eye back into the picture. The diagonals give dynamic movement to what otherwise could be a static subject.

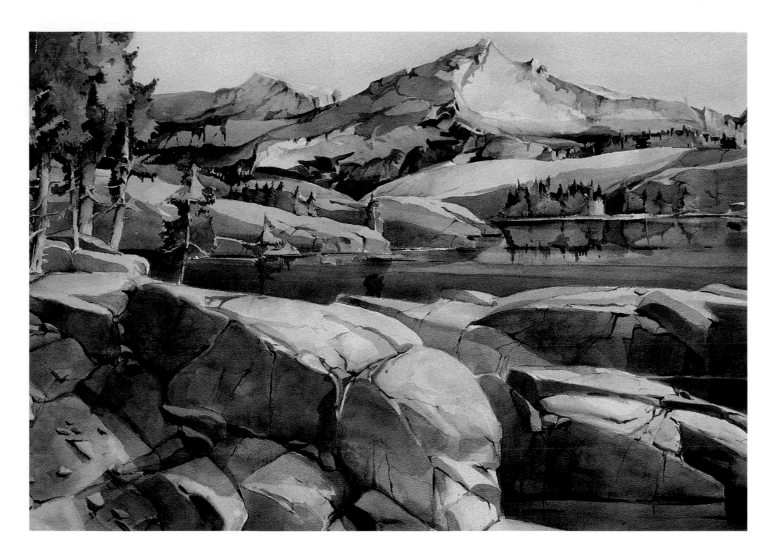

Build on an Underlying Structure

High Country Meditation
Dale Laitinen
29½" x 41"

"I am drawn to the rugged topography of the West," Laitinen says. "In my paintings, I strive to express the strength and power of this landscape through the use of a strong underlying compositional structure. The translucent properties of watercolor allow me to maximize this structure, as well as depict the strong, clear light so common to the region.

"I want to achieve a geometrically organized composition. By using lines, shapes, and negative space, and by uniting the composition through repetition, I attempt to form a harmonious whole. Horizontal lines are used for stability, diagonals for tension and dynamic movement, and verticals for strength and monumentality."

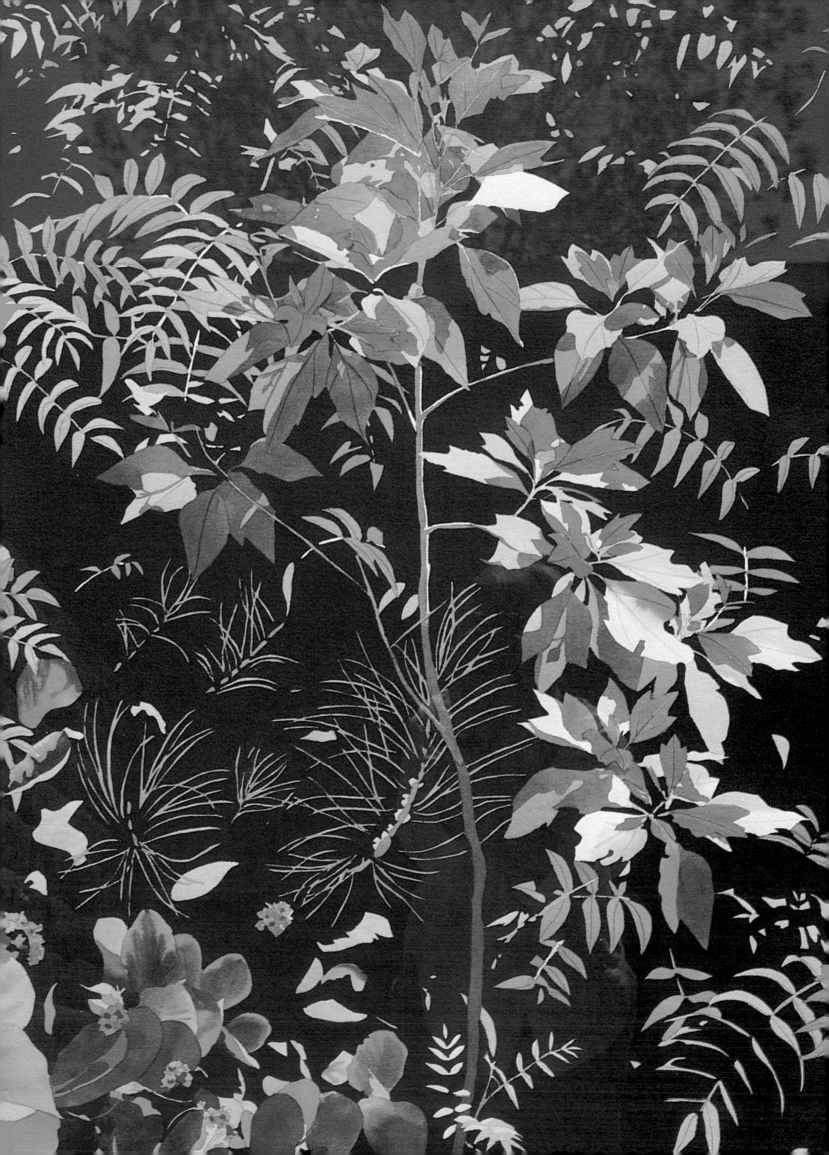

VALUE

Understanding tonal value is the key to better design and composition. With few exceptions, a painting catches our interest by its entertaining patterns of light and dark. This is equally true for a drawing in black and white or a painting done from a palette laden with colors. A successful artist understands that each color on the palette has a specific tonal value in relation to the colors adjacent to it. The deliberate manipulation of these values can create form and space, and heighten drama and mood, while retaining the viewer's interest within the composition.

Foliage
Virginia Pochmann
40" x 30"

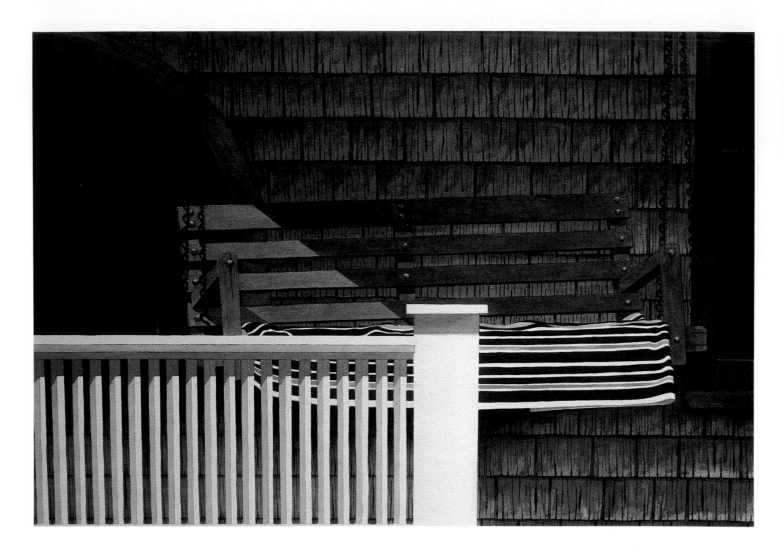

Summer Swing
Barbara Santa Coloma
20" x 30"

Design with Value Contrast

Summer Swing is a scene from Martha's Vineyard, Massachusetts. The strong seaside light is portrayed by the bright, white wooden rail in front of a porch in deep shadow. The design of the painting is made by these areas of strong value contrast. Because Santa Coloma zooms in so close to her subject, the design becomes a study in linear abstract form.

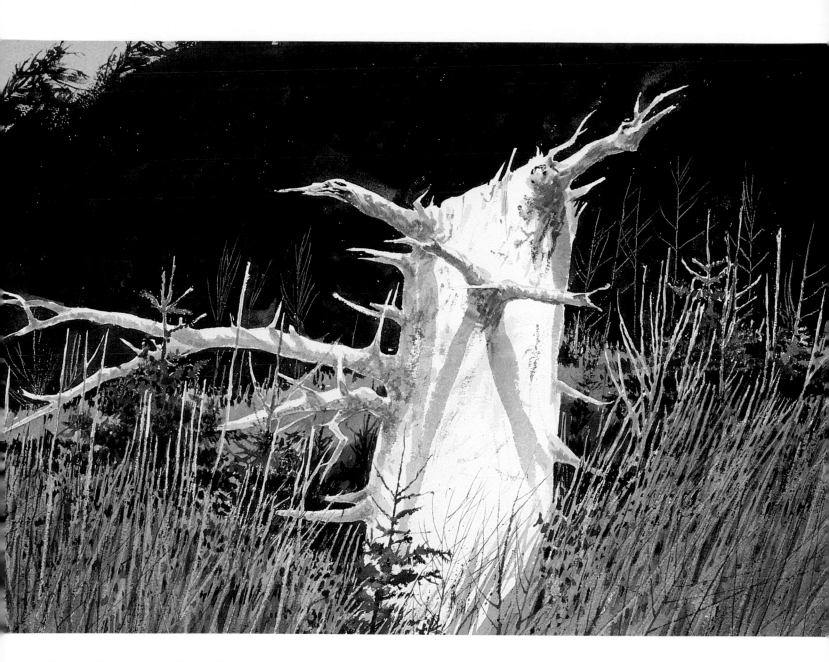

Startle with Stark Contrast

An aged stump on an Oregon hillside facing the Pacific Ocean was the inspiration for this strong value statement. The dark pines in the background create an exciting foil for the lone stump in the rustling grasses. This extreme contrast startles the eye and rivets the viewer's attention. The stark simplicity of the arrangement of light and dark gives great visual power to the image of the wind-blasted trunk, surrounded by the grasses and seedlings bending in the wind.

Windward
Robert Johansen
22" x 30"

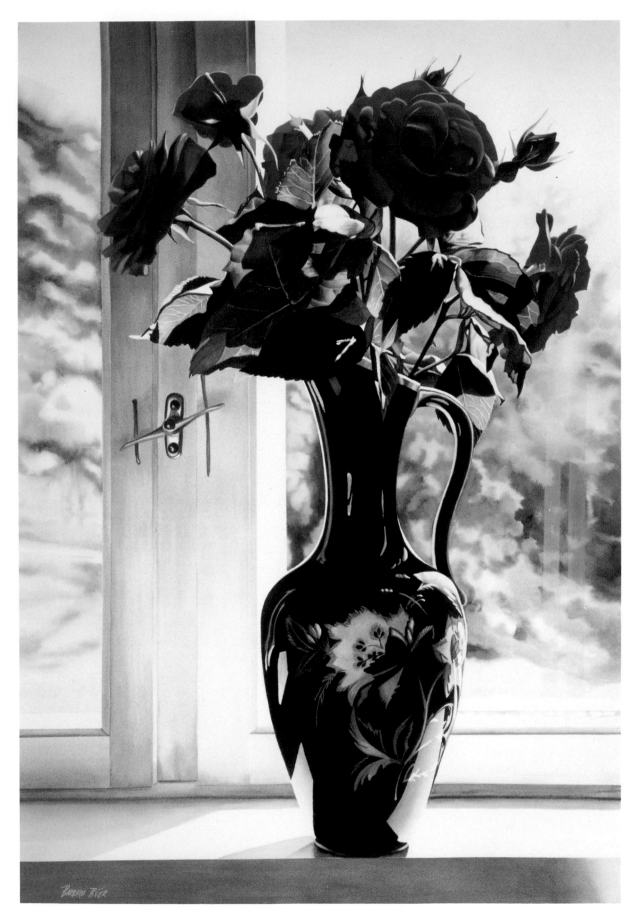

Red Roses, Blue Vase
Barbara Buer
36" x 48"

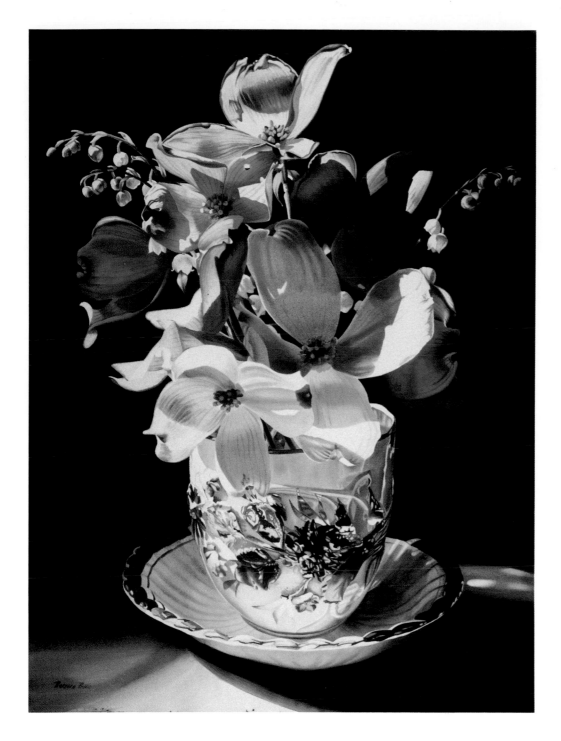

Produce Moods by Dramatic Contrast

Two ways of using strong value contrast are illustrated in these paintings by Barbara Buer. She is fascinated with both strong backlighting, which produces a dark subject against a bright background, and the equally dramatic spotlight effect where the subject is bathed in bright light against a very dark background. The lighting in *Dogwood and Cup* produces a mysterious effect, while the bright sunlight in *Red Roses* communicates a happy, warm feeling. Buer did this painting of roses in Norway. She says, "The extraordinary Norwegian summer sunlight pouring through the dining room window was a component in the success of *Red Roses, Blue Vase.*"

To get the dark background in *Dogwood and Cup*, she painted her subject first with acrylic paint, thinned to the consistency of watercolor. She applied masking fluid over the acrylic, a process that would have pulled off watercolor. Then she applied numerous watercolor glazes to the background. "The use of tonal values in *Dogwood* is what makes the painting," Buer says. "The extremely dark background is what makes the flowers and cup so brilliant."

Dogwood and Cup
Barbara Buer
36" x 48"

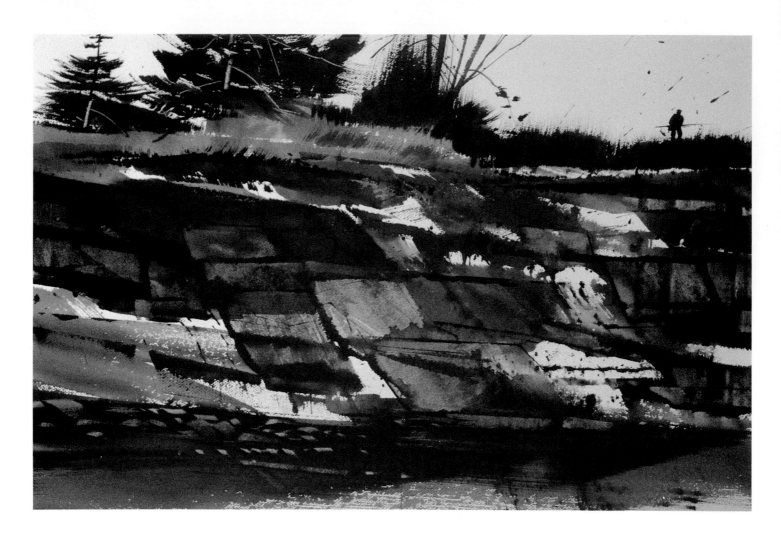

Pennsylvania
Paul St. Denis
21" x 29"

Use Low Key Values to Enhance Mood

"Upon returning from an early spring trip to Cook's forest in Pennsylvania," says St. Denis, "I tried to recapture the mood and feeling I had experienced while hiking in the woods: the warm sunlight on the melting snow, the exposed rock outcrops, the budding rhododendrons, and a lone hiker anticipating spring." Notice how St. Denis accomplished his artistic objective through the use of a low key (values in the darker range) to capture the mood he experienced. The placement of the high horizon line, with the trees and small figure silhouetted starkly against a sky of white paper, accentuates the dramatic relationship of man to nature. The contrast of the strong dry-brushed darks against the white paper emphasized the sparkling quality of the light, and the extreme value contrast creates a powerful lure to attract the eye.

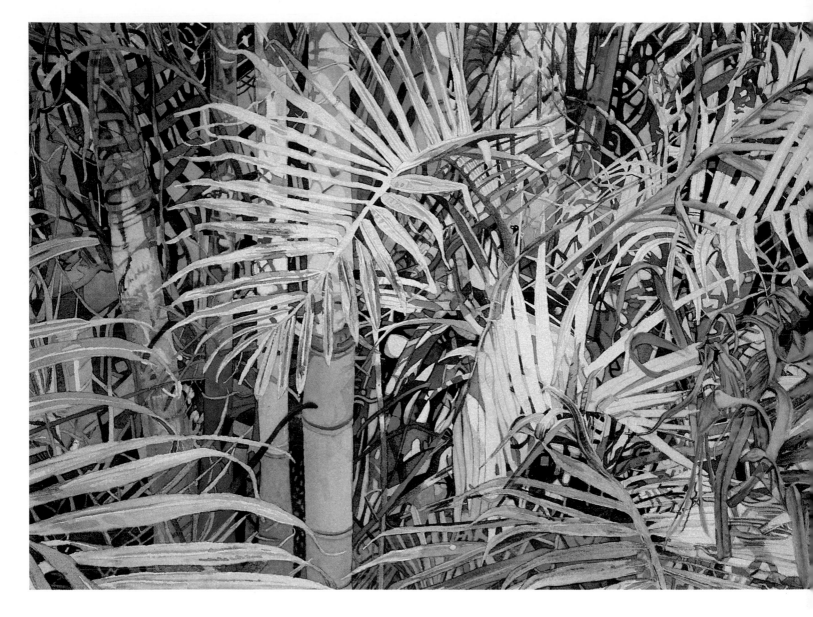

A High Key for a Sun-drenched Look

The idea for this painting came from the image of direct sunlight falling on palm and bamboo fronds that formed a living "privacy fence" around a pool in Florida. The fronds had aged from a green to gold color. The artist's intent was to make every square inch of this painting visually exciting, so the interwoven leaves take the viewer on a non-stop journey around the picture plane. Watercolor is Stamelos's preferred medium because she feels it produces the most intense, yet most translucent colors. Even with all the bright colors used here, she kept the overall value in a very high key (tending toward the light side of the value scale). This was accomplished not by limiting the range of values, which is quite broad in this painting, but by covering the greatest percentage of the paper with the high valued colors. This effectively expresses both the heat and the subtropic light of southern Florida.

Flower Series #125
Electra Stamelos
22¼" x 31"

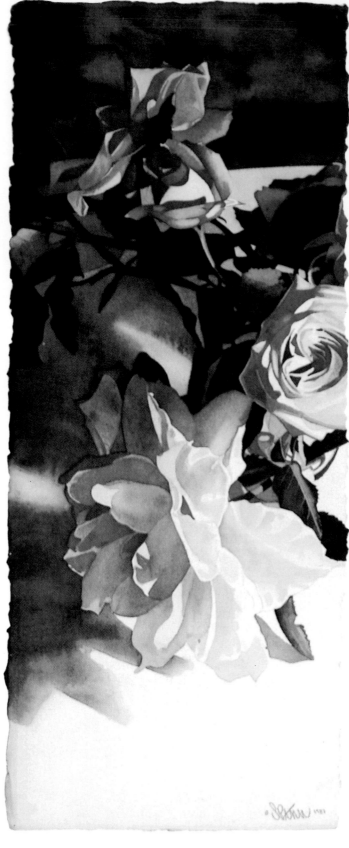

Days of Wine
Susanna Spann
10" x 25"

Nights of Roses
Susanna Spann
10" x 25"

Relate Images with Value

Each of these paintings is composed in a half circle. Together they become a dyptich and form a full circle or a wreath. A full range of values is used for drama and mood as well as to relate the two paintings compositionally. By placing the darks on the top in one and on the bottom in the other the artist creates movement between the two as well as an air of mystery. There is also a contrast of mood. In *Days of Wine*, the blooms reach toward the early morning light, giving a feeling of dawn. In *Nights of Roses*, the shadows become long and soft as at dusk.

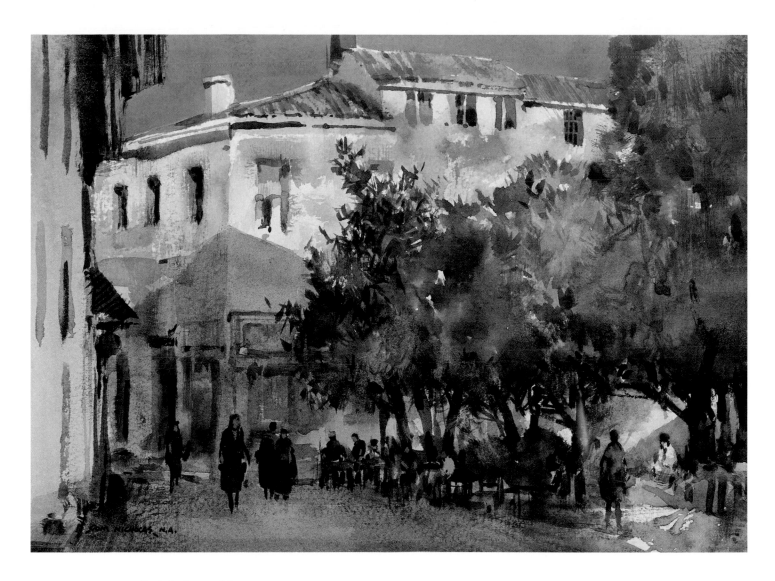

Design with Value Pattern

The dazzling morning light and the textural contrasts between the old walls and the trees inspired Nicholas to do this small painting on location. What makes it work so well is not just his deft handling of the figures in the foreground, but also the strong, simple value pattern he established. Although there is not a strong intensity of value contrast in this painting, there is a clear delineation of large simple shapes. This gives form to the painting and allows us to feel that the foreground figures are in a real space. The irregular slope of the background building in full sunlight, and the light behind the figures on the street below create two balanced centers of interest to focus the viewer's attention.

Plaka, Athens, Greece
Thomas A. Nicholas
6¾" x 9¾"

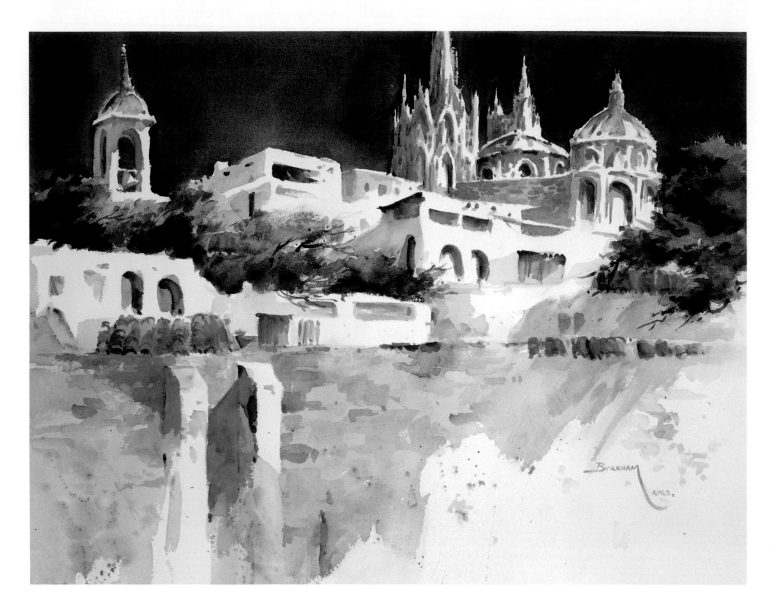

The Jewel of San Miguel
Jane Burnham
22" x 30"

Hold the Viewer's Attention with Contrast

In this painting, the artist felt that simple but strong contrast with little color change was the best way to express the antiquity of this historic village. The strong light from the right, and the dark sky and shrubbery, direct and hold the viewer's attention in the upper third of the picture, focusing attention on the cathedral spires, the jewel of San Miguel.

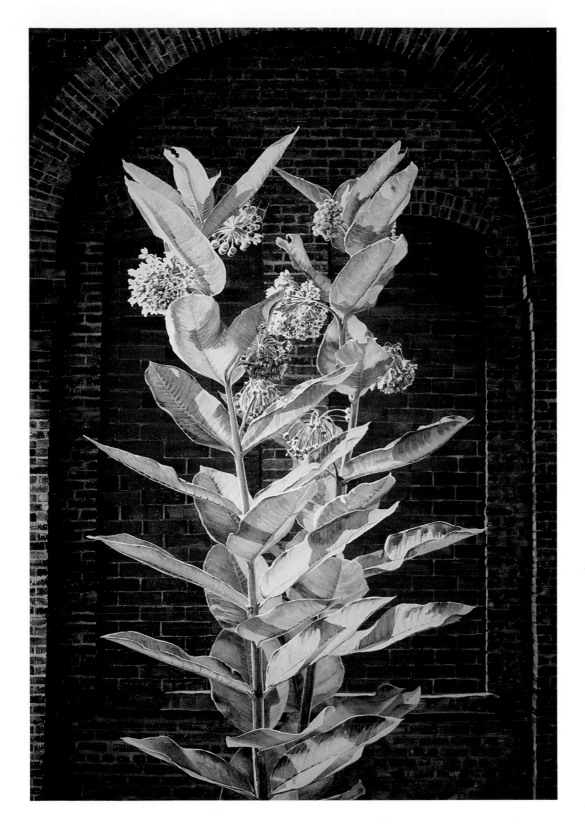

Value Contrast to Express an Idea

The milkweeds that grow in the sidewalks and streets of America's decaying industrial landscape are a symbol of adaptation and renewal for artist Mary Lou Ferbert. The wild plants and weeds are slowly reclaiming the city for themselves. This painting is about the contrast of the living, organic form of the milkweed plant and the manufactured geometry of the brick wall behind it. This contrast is expressed in the value contrast that sets the plant starkly apart

from the background. The artist chose that moment when the sun had just passed over the building, lighting only a few projecting edges of the brickwork while bathing the milkweed in brilliant light. The plant is rendered in bright, transparent pigments; the building in rich, opaque paint. Although the subject is quite commonplace, the artist has used value contrast to elevate it to almost monumental status.

Milkweed and Arch
Mary Lou Ferbert
67" x 40½"

COLOR

Color is the sensuous side of painting. The thought of two colors luxuriously blending together on wet paper is enough to make a watercolorist's heart beat a little faster. Our response to color is individual and highly subjective, no matter how much color theory we have studied. In order to be effective, color needs to work within the fabric of the value pattern and composition. This can mean a limited range of color for some artists, but a full spectrum of saturated color for others. The paintings shown here demonstrate the wonderful luminescence that can be achieved with watercolor.

"Painting is by nature a luminous language."
—*Robert Delaunay*

California Palette
Sandra E. Beebe
22" x 30"

Untitled
George Pate
22" x 30"

Work Loose and Juicy

Pate relies on experimentation and invention rather than on endless brush-strokes to communicate on paper. He starts with wet-in-wet color washes, and even as he refines his shapes, he likes to keep the "loose and juicy" colors spontaneous. In this village scene, he uses a low intensity complementary contrast, along with directional lines, to make the building the center of interest, though it is quite a distance back in the picture plane.

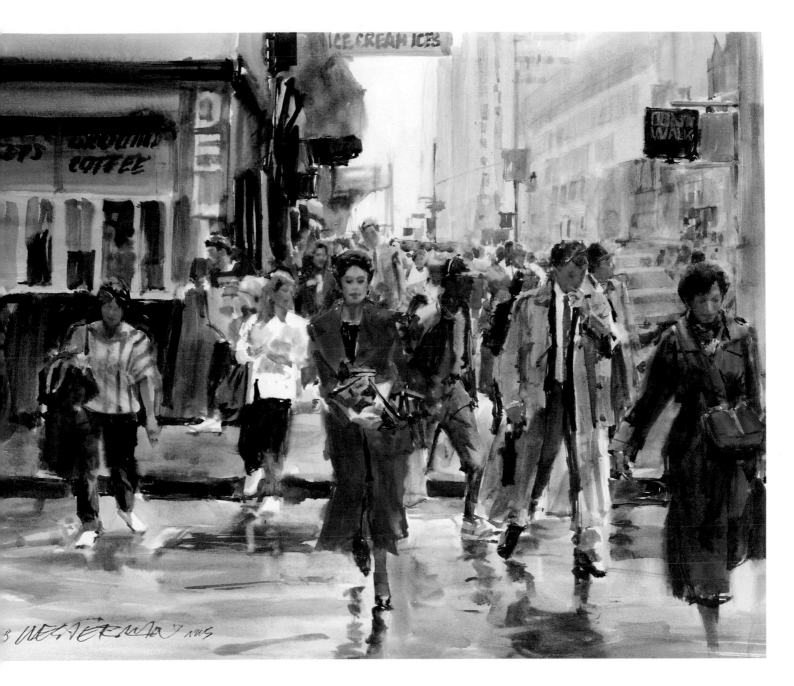

Use Color to Create a Focal Point

Westerman is constantly inspired by what he sees. He says there is a voice inside him telling him to hurry because there are so many great scenes waiting to be painted. In this painting, he wanted to depict the diffused light of a rainy day on a busy New York Street. The scene was so busy with people, signs, etc., that it would have been easy to lose the viewer in a confusion of

detail. To organize and focus the image, Westerman created a strong center of interest by contrasting the fully saturated color of the woman's red coat with gray and creating a secondary interest in the blue coat at the right. Providing these focal points subordinates all the details in the painting and makes it work together as a whole.

New York City:
Woman in Red Coat
Arne Westerman
24½" x 31½"

Deep Red II
Pat Dews
29" x 39"

Achieve Color Unity with Glazes

"What I am shows up in my work," Pat Dews says. "I have a high energy level; I'm effervescent, mostly positive, gregarious, and like to be noticed. My paintings are truly an extension of myself." Rocks and water have always fascinated Dews, and her work is often about the contrasts of the two: between the dark rocks and the white of the water; between the strength of the rocks and the soft caress of the tide; between the durability of rock and the mercurial nature of water. Subtle color changes in the reds, and the warm-cool contrasts create a push-pull that courses through the painting. The tensions created by the play of color are controlled by a glaze of burnt sienna applied over the entire painting. A sense of vastness and serenity is the result. Dews wants her paintings to be noticed from across a room—and they usually are.

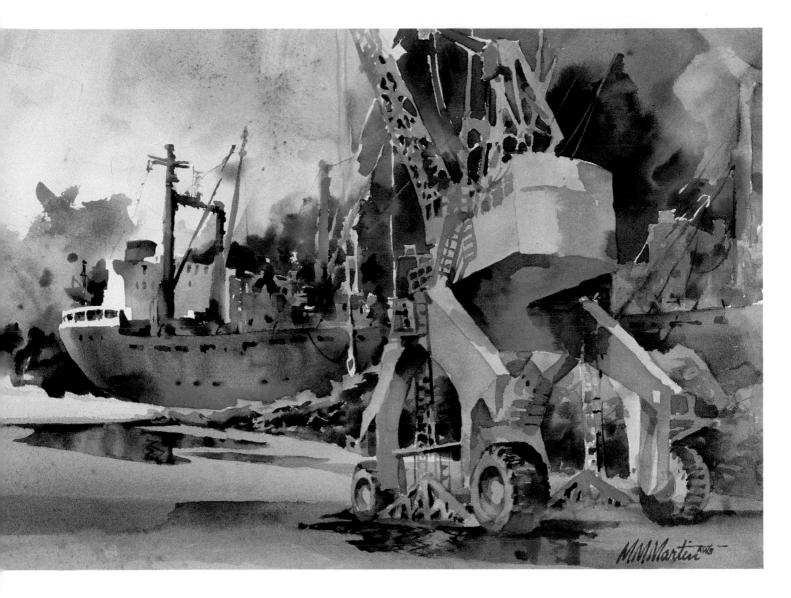

Intensify Color for a Strong Subject

The sounds and moods in the bustling activity of Buffalo's harbor have captured Martin's attention since she was very young. This painting was inspired by a container ship in port and her fascination with the huge yellow loading crane. The sky was actually gray and close in value to the yellow of the crane. However, to give it the powerful presence she experienced, she chose to intensify the color and value of the sky behind. She decided to use phthalocyanine blue and to use it at full intensity against the areas of the crane she wanted to emphasize. She felt that the strong color contrast was appropriate for the "heavy-duty" industrial activity of this port.

Any Day at Port
Margaret M. Martin
22" x 30"

Way to Rubidoux
Don O'Neill
21" x 29"

Design with Low Intensity Colors

"I don't think of myself as a 'colorist'; I look at myself as a value painter," says O'Neill. "While I paint I do not think directly of what colors I wish to use... rather I think temperature." The play between the cool shadows and warm foliage in *Way to Rubidoux*, along with the bright white passages, is what makes the painting work. O'Neill starts many of his paintings with the "mud" left on his palette. He never uses color straight from the tube, but adds colors to the mixture on his palette to make it warmer or cooler. In this painting, the small figure on the path is clothed in the only (relatively) bright colors, making him a point of interest.

Overlay a Finishing Wash

Knott has always had a passion for wooden boats, and she became totally involved in this large painting. She worked rapidly to develop contrast, making bold statements of color on the boats with quick strokes. The alternation of warm and cool colors was exciting to the artist. After some finishing details were added, she overlaid a wash of Antwerp blue on the entire painting to reflect the color of the sky and then a wash of raw sienna, reflecting the sun, in order for the image to be an integral part of its surroundings.

Passages
Dee Knott
36" x 42"

The Line Up
(Litter Series 14)
Sandra E. Beebe
22" x 30"

Begin with Strong Color

Sandra Beebe finds color and pattern in all of life's objects. *The Line Up* is part of her Litter series, featuring arrangements of objects many people would consider unworthy of art. Her bright colors and strong design patterns give her paintings wonderful vitality and energy, yet are the result of deliberate control. She projects slides of her found objects onto 22x30-inch cold pressed Arches paper to transfer her drawing. She then begins with a strong color, such as a bright red, because she feels it is important that she "love the painting from the first brushstroke." She works carefully, using thin washes or heavy coats of color to build up the appropriate color intensity. Much thought is given to the placement of colors. Reflected colors, shadow colors, and highlights are strategically positioned to maximize visual interest while maintaining unity.

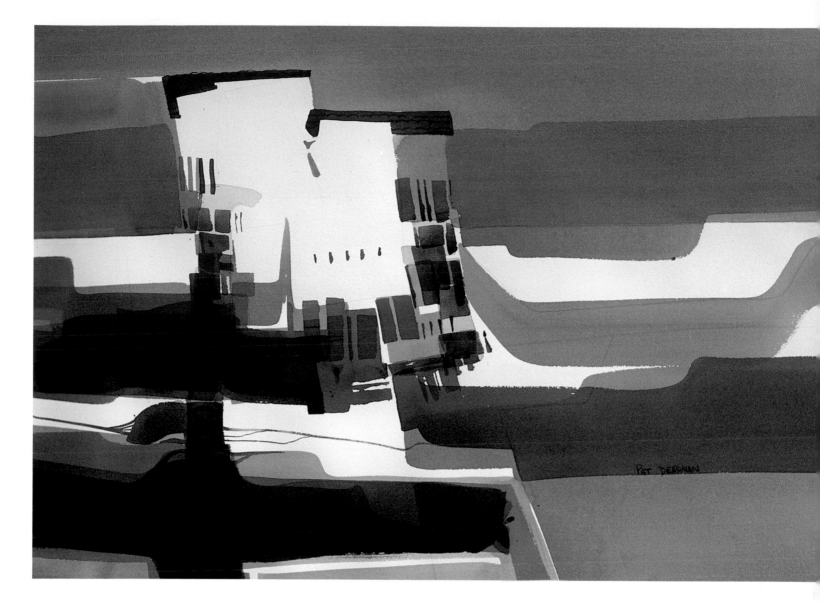

Use Primary Colors for a Minimal Statement

In this painting, Pat Deadman wants to share her reactions to the Texas Gulf Coast where she lives, with its condominiums, surf, and dunes. She uses a simple arrangement of flat contrasting shapes in primary colors (blue dominance) along with a strong pattern of white to express this. The white pattern, traveling easily over the flat primary blues, takes viewers through the painting on a horizontal path, enabling them to feel the coastal landscape, interrupted only by the man-made shapes. Deadman says that when she paints more complicated subject matter her palette changes to include more grayed, subtle tones. But in this work, the primary palette helps to achieve what she describes as a "minimal statement; less on the page. Save something for the next painting!"

South Padre Island
Pat Deadman
22" x 30"

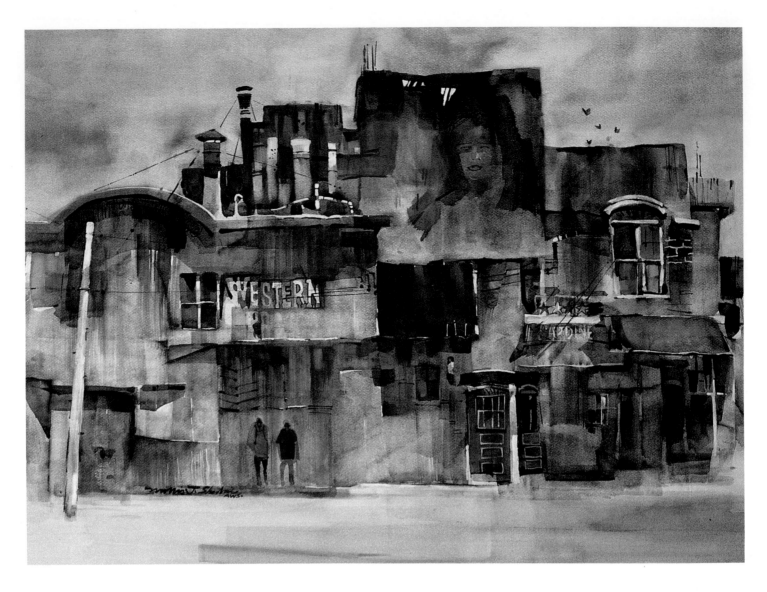

**Maria, Cannery Row,
Monterey**
Morris J. Shubin
30" x 40"

Let Your Color Evolve

Shubin's intention was to interpret this scene in a personal manner, restructuring the building, adding more shapes and patterns of rich color and textured surface. He began by saturating the paper with color, wet into wet, and then adding more color while the paper was still moist. When dry, he redesigned the shapes of the buildings and sponged out any unwanted color, leaving stains. Shubin likes to work by bringing amorphous color and form slowly toward content. He feels this method permits him to use his imagination and challenges him to express an idea in a unique way.

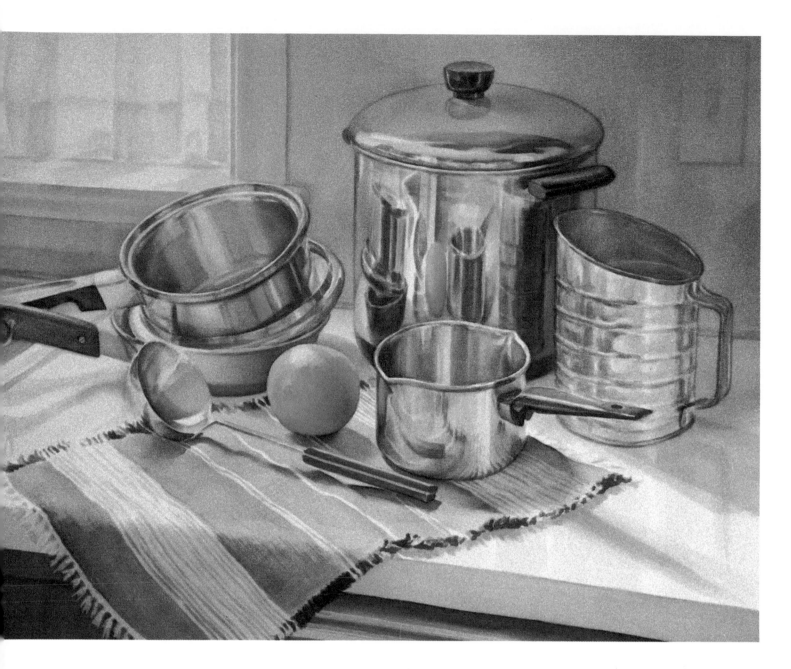

Accent with Color Temperature

Priscilla Taylor Rosenberger finds watercolor a very satisfying way to paint the colors and textures of simple everyday objects, which she chooses less for their association with common usage than for their formal beauty. She paints from direct observation, where she can study all the subtle colorations of her chosen objects. In *The Orange*, her colors are built up in many layers, using many colors other than black to capture the silvery reflections on the metal, such as violets, blues, even Windsor green. The extensive use of these colors sets up a cool dominance in the painting. The perfect foil to the cool, shiny metal, she says, is the "character actor"— the orange. The various reflections of the orange form a web of warm accents to ensnare the eye's attention. This warm-cool contrast is the "plot" of the painting.

The Orange
Priscilla Taylor Rosenberger
22" x 29½"

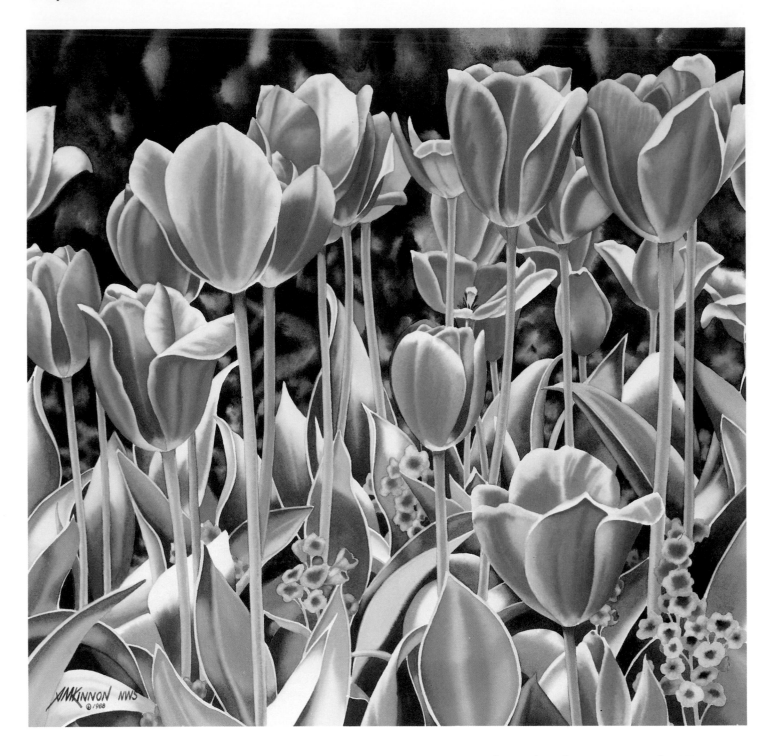

Dutch Treat
Susan McKinnon Rasmussen
21½" x 30¾"

Guide the Viewer's Eye with Color

There are so many gray and rainy days in her state of Oregon that Rasmussen likes to capture the warm, sunny ones year-round in her paintings. In *Dutch Treat* she used bright colors, strong value contrast, and the white of the paper to capture a feeling of sparkling sunlight. The warm, bright colors of the tulips were placed against the cool darks of the background. The repeated colors of the flowers form "stepping stones" to bring the viewer's eye into and around the painting, giving us what Rasmussen calls a "bee's-eye view" of the garden.

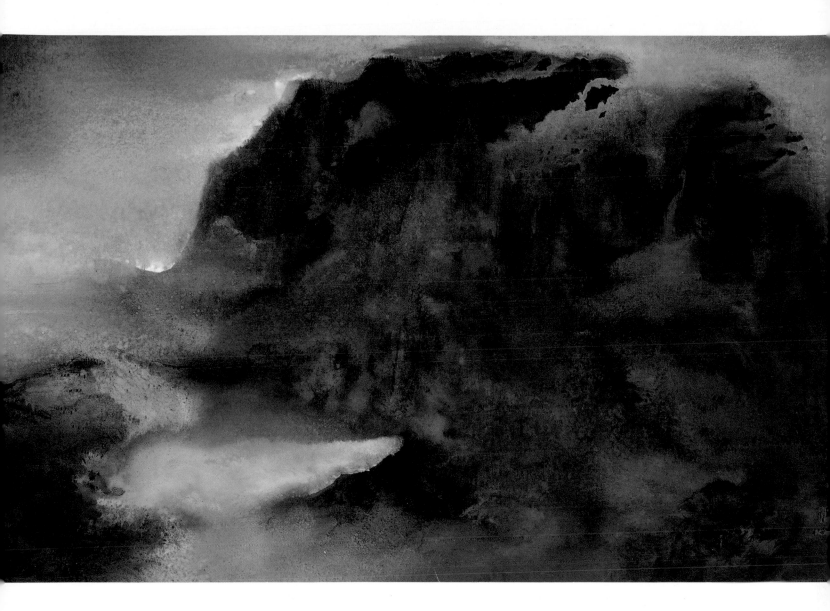

Give Colors Room to Move

Diana Kan was born in Hong Kong and combines the most exciting aspects of Eastern and Western painting, with both the old and the new. In painting *Moving Mist* she used the ancient Chinese technique called Po Mo. Po Mo means using your knowledge to break through the color. Basically, the technique is to splash the color onto the canvas and let nature take its course. But rather than being a simplistic technique, it's a skill the painter must develop over decades of traditional training. The knowledge and experience a painter develops through this training enable her not only to see, but to have deep insight. Kan has used a warm-cool contrast in an open way that seems to give the colors room to move and breathe within the dimensions of the painting.

Moving Mist
Diana Kan
24" x 36"

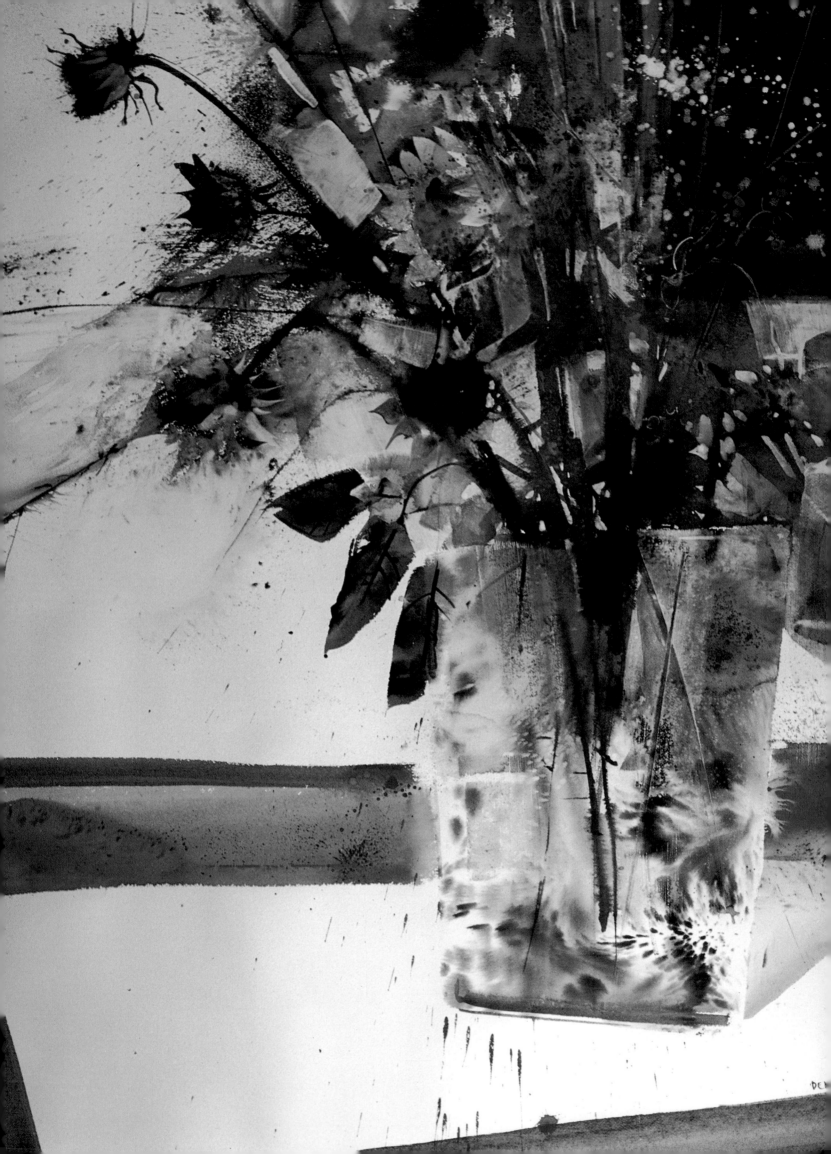

TEXTURE AND PATTERN

O nce attention is gained by design and color, texture is often a way to sustain and increase interest in a painting. Watercolor is probably preeminent among painting mediums for its unending variety of textures. Its transparency and movement, and its ability to interact with other substances, are just a few of the qualities that seem to encourage experimentation. Some of the paintings here use repetitive patterns rendered with exacting brushstrokes, which can be seen as "big" textures. Others highlight the juicy qualities of the paint itself, while still others use special techniques to produce unusual effects.

"The people and easels rising from the floor are the big textures of the floor. The lines of the boards, the spots of old paint and dirt and the general neutral color of the floor, are the minor textures."

—*John Sloan*

Sunflowers by the Sea
Paul St. Denis
43¾" x 34"

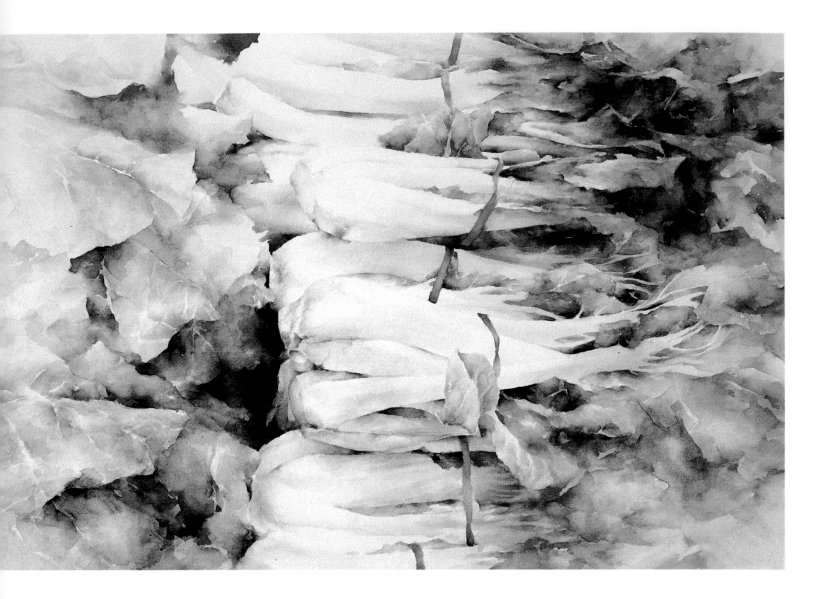

Bok Choy
Frances Miller
24" x 32"

Come In for a Close-up View

This painting was inspired by the visual rhythm of the bok choy Miller saw stacked in the grocery. She has employed her favorite approach to painting here, letting the work evolve on its own. She developed this one through "sculpting" with overlapping washes, pushing and pulling the lost and found edges. She used these hard and soft edges to evoke the sensuous flowing feeling of natural forms and to express the random patterns found in nature. The irregular textures of nature agree with the effect she hopes to capture in her work, a poetic or ethereal atmosphere.

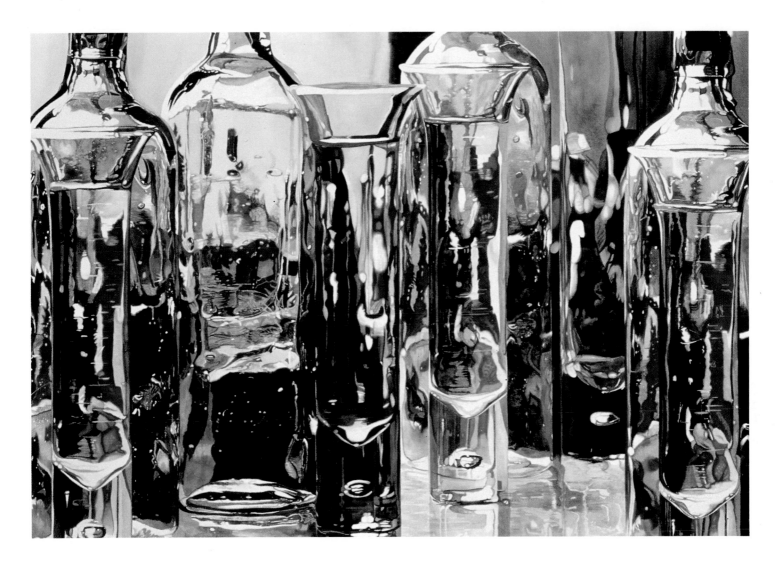

Multiple Glazes for a Rich Matte Finish

Cajero describes her work as being sometimes mysterious, sometimes romantic, often playful. "It is mysterious when abstraction and form melt into one another; it is romantic in lushness of color and brilliance of light, and it is playful when the interior "dance of light" is particularly delightful." Cajero captures the sheen and glint of her favorite subject matter by building up layers of color. Using only transparent watercolor, she glazes an area with many washes, drying each glaze quickly with a hot air dryer to get a rich matte finish. She does not often mix colors, but relies on the pigments straight from the tube in order to retain the brilliance and saturation of the color.

Mirage VI
Meg Huntington Cajero
30" x 40"

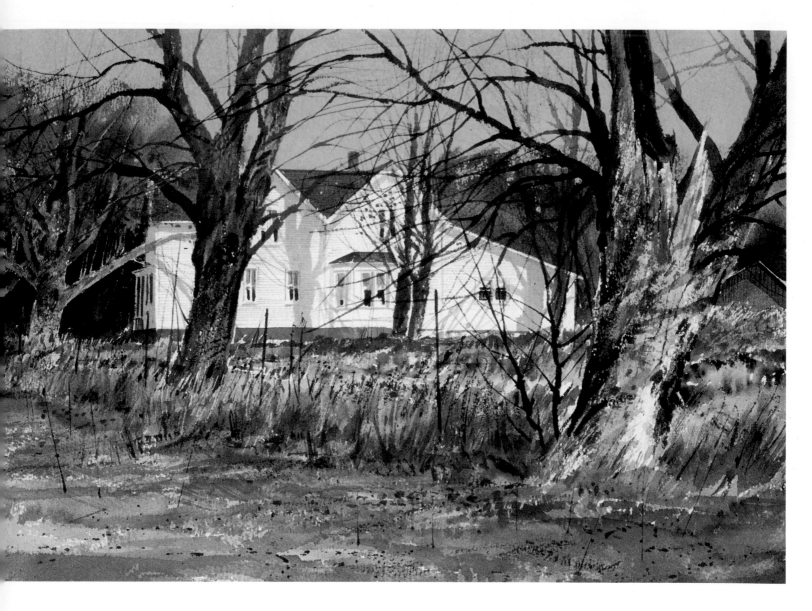

March
Robert Johansen
20" x 27"

Drybrush for a Weathered Look

The sketch for this painting was done in March. The winter snow had melted but the grasses were still shades of brown. The sunlight had traced silhouettes of the trees against the brilliant white farmhouse, while the dried grasses created a rich texture in the foreground. Johansen used a dry brush technique on the grasses and tree trunks to give them a weathered look. He further developed the textures of the grassy areas by scrubbing them with a brush and spattering them with darker colors.

Create Texture with Rice Paper

Snow Ridge
Pat Dews
6" x 6"

"Rocks are a favorite subject of mine. I like their strength, color, and texture," Dews says. "They lend themselves perfectly to the surface texture I love to create. Since I paint them any color I want, and any size, the variations are endless." In this painting, Dews used rice paper in mostly earth tones, cut and torn in natural shapes to create a raised texture. She wanted very strong patches of white snow, so she used torn edges to make them stand out. Strong color and values are the substance of the painting's strong design. Within the small square format, the lush textures draw the viewer in for a closer look. The silver and gold make you feel as if the painting were a treasure—a small gem.

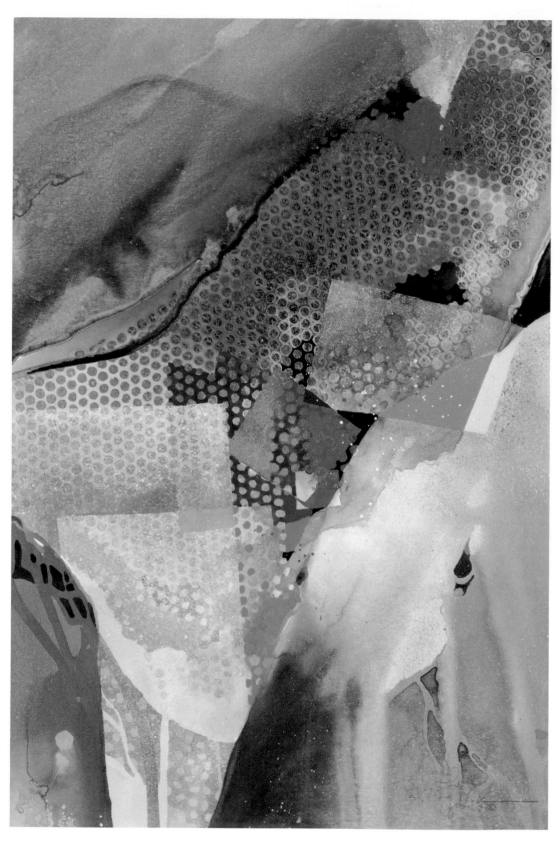

Floating Fragments
Dorothy Ganek
30" x 20"

Add Interest with Repetitive Texture

The theme of this painting is the contrast of textures and shapes. The soft amorphous gray forms contrast with the hard-edged white and violet shapes. These weave in and out, leading the eye to the warm square in the center of the painting. Ganek made the interesting dotted texture by laying a plastic bubble pack onto the wet washes. She allowed the paint to dry before lifting the plastic, which formed the tiny circles. The use of this texture adds a great deal of interest to this abstract work.

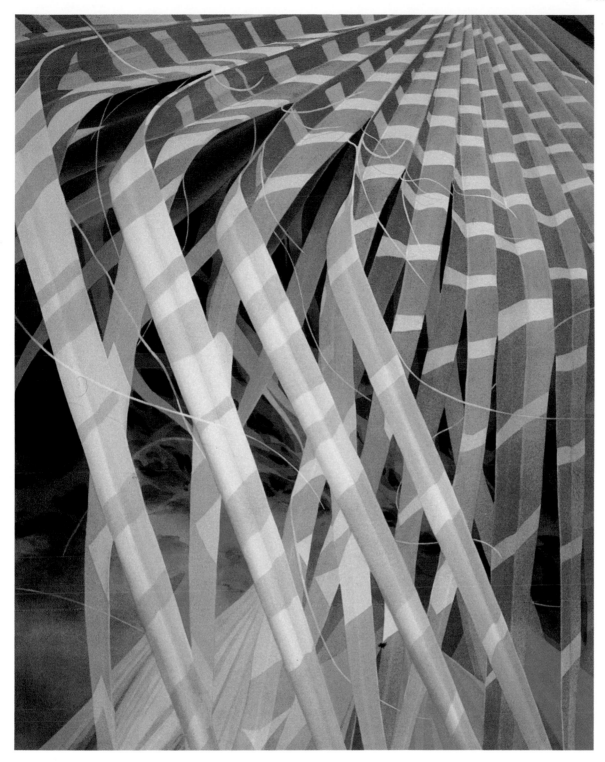

Create Visual Rhythms

Palm Patterns #118
Edith Bergstrom
38" x 30"

All of Bergstrom's paintings have the same name, followed by the sequence number. She paints palms because she finds their rhythms, shapes, and orderly growth patterns more exciting than any other subject matter. In developing a composition, she looks for a dynamic pattern of shapes. She takes a close-up view so the design is appreciated before subject matter is even recognized. This view also reduces peripheral distractions and causes the viewer to notice things he may never have seen before. Bright sunlight is a feature in all her work

because it allows for the widest range of values, a feature equally as important as shape to the pattern orchestration. In this painting, a palm leaf above and out of the picture casts a cool blue shadow on the gold leaf below, producing a woven basket feeling. The crisscrossing diagonals beat varying rhythms from fast in the upper right to almost lazy in the middle and lower right. Bergstrom says, "The eye loves repetition, but does not want to be bored. It likes familiarity, but needs surprises."

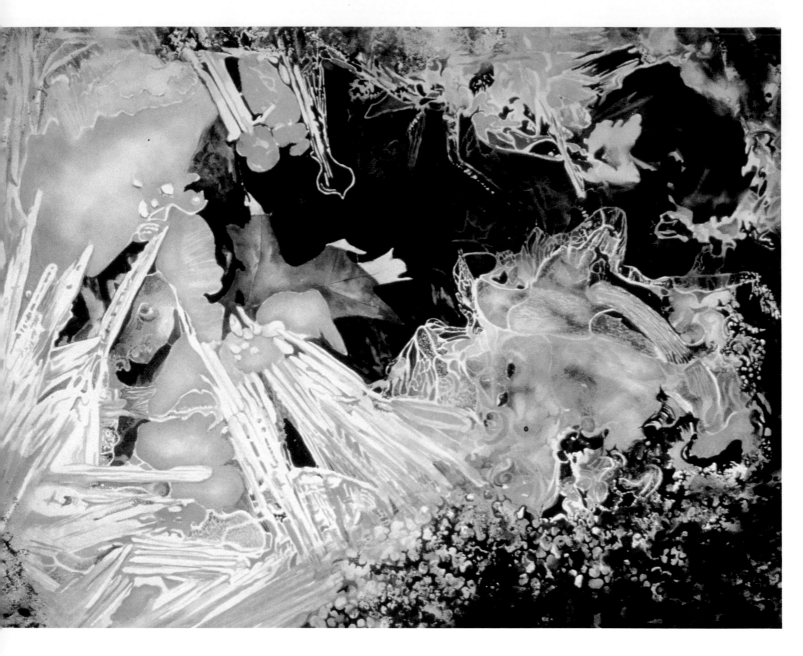

Catch 32°
Carolyn Pedersen
28" x 36"

Find Nature's Hidden Textures

"I love texture," says Carolyn Pedersen. She has always been fascinated with texture in both nature and in painting. "The concept behind this painting was to show nature's hidden abstractions... I 'found' my idea during a January thaw while exploring a neighbor's field. I enlarged something very small, delicate, and easily missed to a position of grandeur." Much of the grandeur in *Catch 32°* is due to the abstract pattern cre-

ated by the textural contrasts of her subject matter. The larger areas of ice are contrasted with the lacy crystals and the dark depths of the water. Most of the texture of this painting was achieved by painstakingly painting around each small ice crystal. No masking agent was used. Some texture was created by applying paint to a piece of Plexiglas and pressing it on the paper; other textures were built up layer by transparent layer.

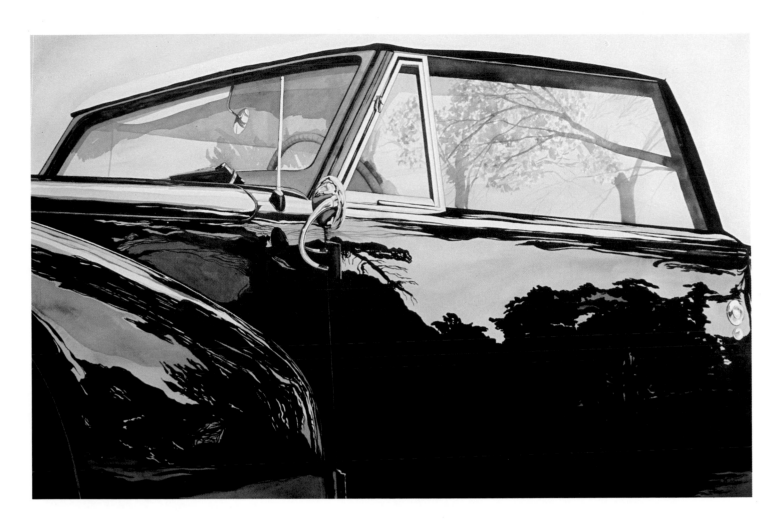

Capture the Shine of Polished Metal

Reflections are often difficult to paint, not because they require technical virtuosity, but because they demand very careful visual scrutiny. What makes highly polished and reflective surfaces look so shiny is that the *surroundings* are so clearly and precisely visible. People rarely look at all the fine details evident in such reflections, but the artist must see them in order to render the illusion correctly. In *Lincoln Reflections* Munday has carefully examined what is visible in the mirror-like polish of the car, and has accurately transcribed what he sees. The result is a painting that dramatically captures the shine of polished metal.

Lincoln Reflections
Charles Munday
18" x 22"

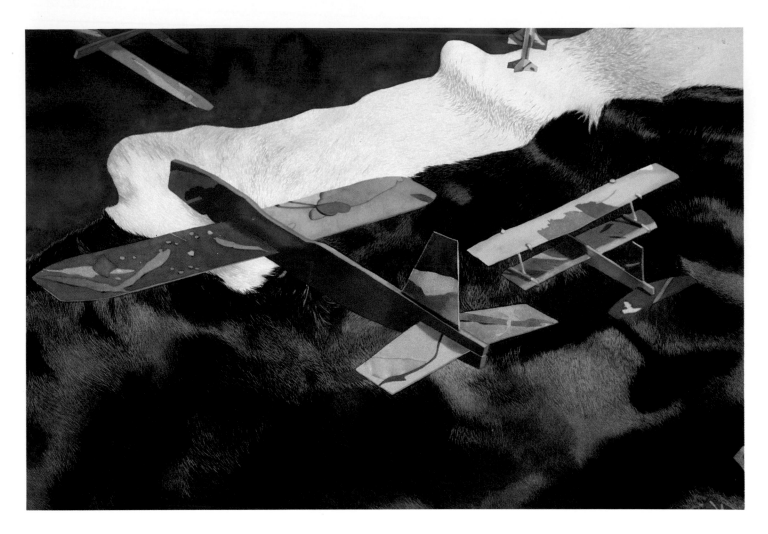

*Domestic Flights 1707 &
1709 over Cowhide, TX*
Elizabeth A. Yarosz
40" x 60"

Texture can Enhance Narrative

The numbers 1707 and 1709 are the addresses of the side-by-side houses owned by the artist and her printmaker husband. They live in one and work in the other. The dense texture of the cowhide becomes a playful allusion to landscape under the comfortably floating balsa airplanes. Yarosz wants the viewer to be "wrapped in a soothing and un-troubled journey" in which companion-ship is expressed as well as individual-ism. If there is an obsessive aspect of this painting it is in the execution of the hair on the cowhide. The area was saturated with layers of paint and allowed to dry. Then each line of hair was lifted out with a small flat brush. "Illusion, real surface space, and imagined space are integrated in this picture," Yarosz says. "Pictorial enrichment on several levels is my concern."

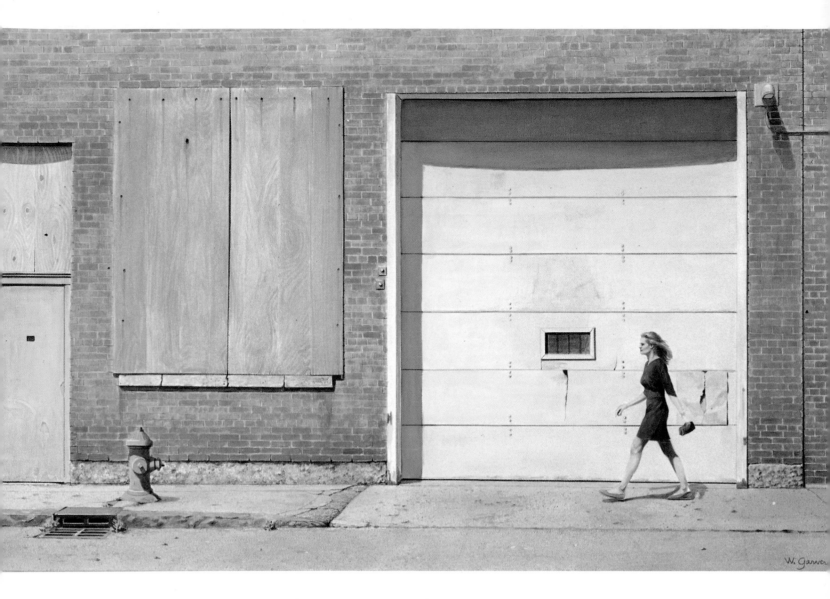

Express Your Theme with Pattern and Texture

In *Lady in Red* Walter Garver combines two themes that have long fascinated him: the weather-worn facades of buildings and the contrast between youth and age. The pattern of repeated rectangular shapes organizes the painting and focuses attention on the figure through contrasts of shape and color. The woman is animated by the visual connection the eye makes with the fire hydrant, the only other strong vertical in the painting. The figure's vigorous stride suggests the vitality and energy of youth, while the building represents the ravages of time. These dual concerns are expressed largely by the patterns and textures of the painting.

Lady in Red
Walter Garver
17" x 28"

STYLE

tyle is elusive. If sought after, it is never truly found, but if ignored, it finds you. In one sense, every artist cannot help but have a style. Just as everyone has a different handwriting, one cannot paint with someone else's eyes or hand. That in itself makes each artist unique, but a really original painting style is more than that. Painting is a process that begins as an attempt to use color, value, and other elements in a pleasing way. As one grows, this can be done with more and more confidence. However, it is when an artist grasps not only technique, but what it is he or she alone has to say, that a blending occurs between motivation and skill. At that time, the artist can be said to have truly developed a style.

"If you could say it in words, there'd be no reason to paint."
—*Edward Hopper*

Feather Light #3
Linda L. Stevens
42" x 29½"

Garden of Jade
Barbara Wagner
27½" x 32½"

Revitalize a Common Subject

Wagner is committed to painting flowers. She enjoys the challenge of painting them in new and exciting ways and strives to keep her paintings looking relaxed, fresh, and easy with many colors and parts woven into a harmonious whole. In *Garden of Jade* she decided to break up the composition with geometric shapes, letting each section say something a little different about flowers. The geometric shapes add interest and variety; they remain distinct, yet work comfortably with the rest, creating something of a watercolor sampler. The complexity and rich colors give a slightly mysterious, oriental feel to *Garden of Jade*.

Experiment with Surfaces

Bill James is known for his impression-istic pastel paintings in which he allows the individual strokes or squiggles of color to remain visible. The viewer's eye blends the colors together, while the strands of color give the paintings a special vitality. When James began painting with watercolor, he was looking for a new and different way to work. Taking a tip from the work of Burt Silverman, he experimented with painting on gesso-covered board. The slick surface permitted the watercolors

to dry in patches with distinct hard edges, unlike the softer edges the paint forms on ordinary watercolor paper. The smooth surface created an effect not unlike the strands of color in his pastel work.

The bold and colorful pattern of this man's shirt attracted James' interest. The brightness of the pattern was contrasted with the serious look on the man's face, and with the darker values of the background, creating both visual and psychological contrast.

The Flower Shirt
Bill James
20" x 15"

Fossil Field III
Michael Schlicting
22" x 30"

Find Abstract Possibilities in Nature

Gathering ideas from the rocks and strata along the beaches and headlands near his Oregon coast home, Schlicting approaches his paintings in a sculptural, tactile way. He prefers a strong, low light source to create dramatic shadows and give the illusion of a shallow depth of field. This adds to the sculptural effect he's after. "My work has always been rooted in the abstract compositional possibilities found in nature. That, however, allows me a very wide latitude, from painting my coastal environment to the exotica of my travels. Because, of course, the abstract possibilities are everywhere we care to look for them."

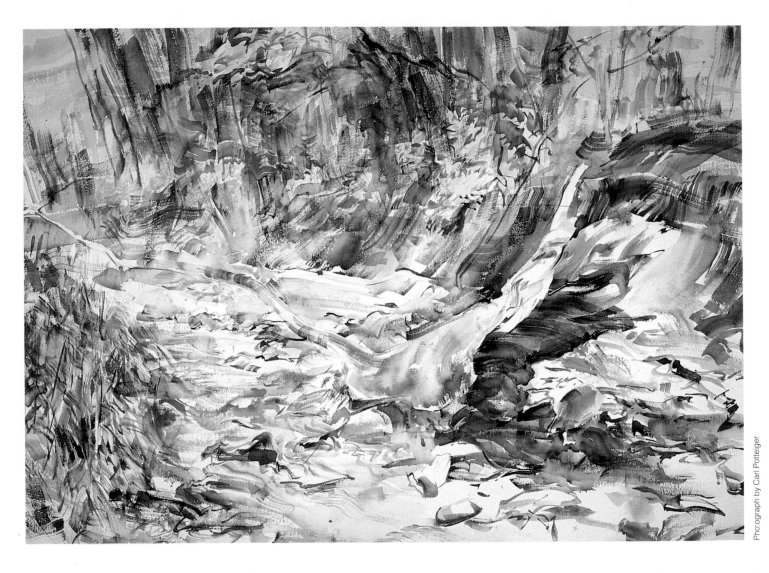

Blend Abstraction and Representation

Environs of Pamajera #56
Alex McKibbin
29" x 40"

Alex McKibbin shows us how we can have it both ways: His paintings offer us recognizable subject matter, but the pattern of gestural energy is almost abstract. His short, colorful brushstrokes build up texture and identify the natural objects he is painting, and animate the composition at the same time. Look closely and you can see and enjoy the pattern of colors and the calligraphic flourishes of the brushstrokes. If you step back and view the whole painting, you can see how these patterns add up to a landscape with depth and atmosphere. He rarely uses broad washes of color, preferring to build up his shapes using rich, pure color in small, textured strokes. He often prefers to use bristle brushes instead of traditional watercolor brushes. "My brush seems guided less directly by my eye than by a kind of motor empathy with the rhythms, weight, and tensions of the elements of the landscape before me. I have worked toward capturing a certain primeval, 'before the hand of man' quality."

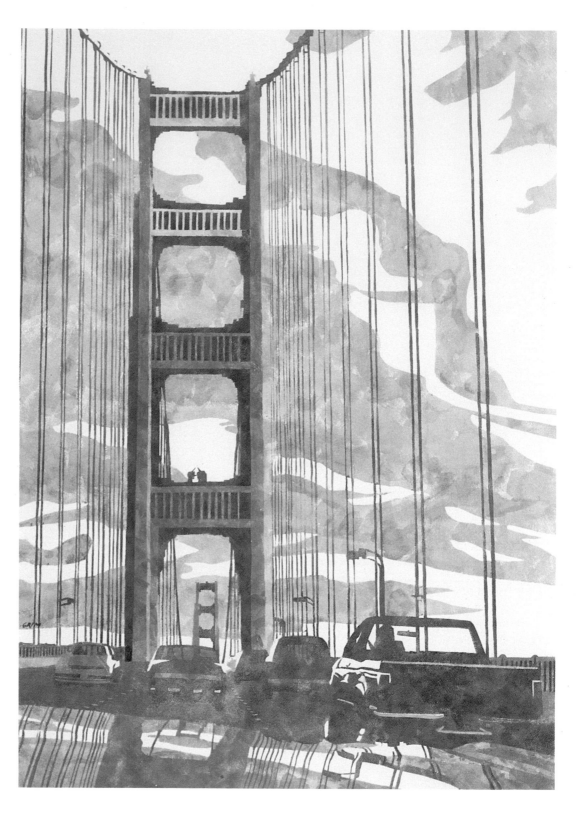

Golden Gate
Ellen Grim
30" x 22"

Evolve Patterns from Realism

"I envision never losing the recognizable but becoming more and more abstract in the rendition. I want to see patterns evolve from realism," says Ellen Grim. In order to achieve this, Grim set up a careful geometric design using strong verticals and horizontals. She masked the edges of the bridge components and the vehicles so they were in clear contrast to their surroundings. This creates the clean crispness she likes. Another technique she uses to lift this painting out of the purely realistic is the elimination of shadows. This brings her recognizable subject matter into the realm of personal interpretation. One often sees the Golden Gate pictured with little emphasis on people, but Grim wanted to portray the bridge in relation to them. Her strong design and the unnatural lighting help unify the bridge and the people who use it.

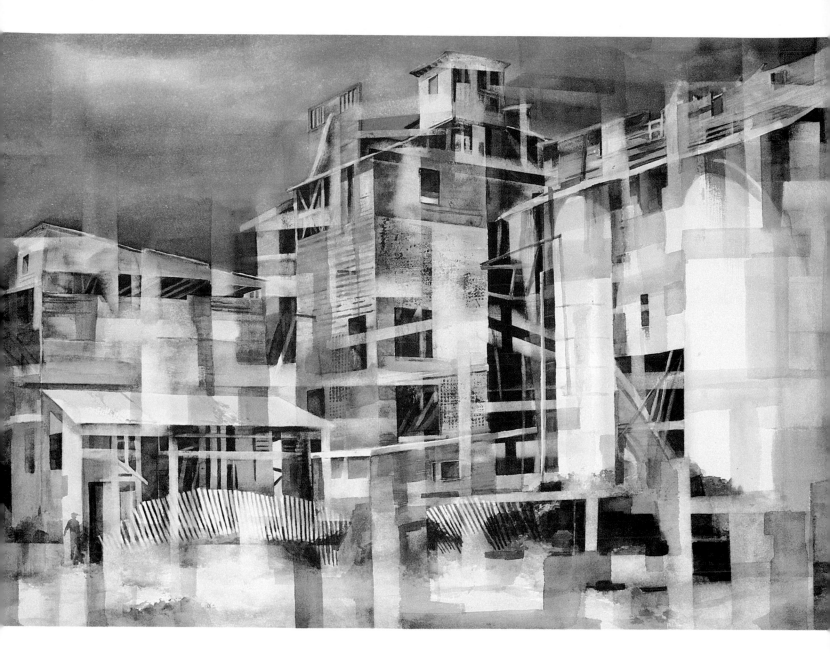

Suggest Structure with Geometry

Betsy Schneider became fascinated by
strong geometric shapes and the patterns
of light and dark within those shapes
after moving to California. She began
painting old barns and houses on loca-
tion. Eventually she decided to suggest
structure, rather than describing it
literally, by alternating negative and
positive shapes. One technique she used
to accomplish this was to lay down tape
over a previously applied color and lift
some color with a damp sponge. The
repetition of line, shape, and color
achieves a rhythm that helps unify the
complex structure of the picture.

Out of the Past
Betsy Schneider
22" x 30"

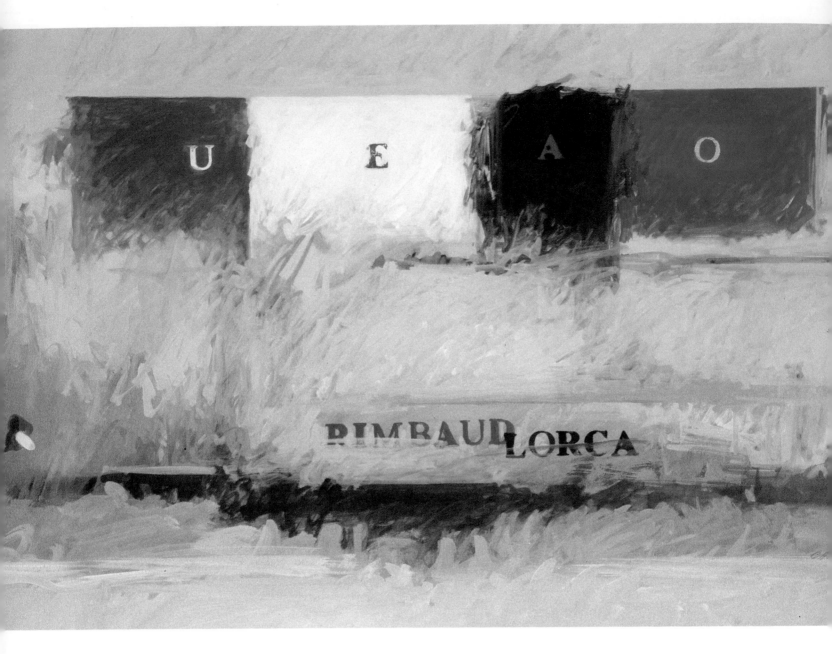

The Poets
Salvatore Casa
24" x 30"

Find Inspiration in Literature and Letters

Salvatore Casa's work is inspired by literature, music, and the history of art. Letter forms and words are often components of his paintings. The idea for *The Poets* began to grow when the artist read that Rimbaud, the French poet, had given letters of the alphabet specific colors. This idea sparked a series of over twenty-five paintings.

Casa paints with casein on gessoed rag paper mounted on board, a surface that reminds the artist of wall painting. In fact, a number of his paintings include an image of paper or photographs pinned to a wall. Casa applies the paint in a brushy, gestural style reminiscent of the Abstract Expressionists, creating a surface that is rich and painterly.

Let Your Surroundings Suggest a Style

Mary Sweet uses flat areas of smooth, opaque paint, with no shading and no gestural marks. She began to use this technique after moving to New Mexico and feels she probably wouldn't have adopted it had she stayed in California or in her native Ohio. The air in the Southwest is clear and dry, so the contrast between sunlit areas and shadow is quite clear and striking. Sweet tries to capture this contrast with her flat technique.

Autumn, Sandia Peak
Mary Sweet
15" x 22"

Crossroad
Kwan Y. Jung
25" x 32"

Combine Two Cultures

Jung was educated in traditional Chinese watercolor painting and later in the Western school. He likes to combine abstract and representational qualities, implying aspects of nature rather than being explicit. In his words, "A good piece of watercolor is expressed by heavy washes, calligraphic lines, forceful spirals, luminosity of colors, and chromatic freshness."

Try Casual Realism

"My style is 'casual realism', which can give a more direct, simplified feel to a subject than photographic realism. My goal is to keep painting what I see, do it simpler, with more feeling, design, and less drawing," says Delaney. In *Barbados Street*, the woman in pink was painted in neatly to contrast with the looser, wet-in-wet style of the buildings. The cool shadows complement the warm sunlight to give us a clear sensation of the old section of Barbados.

Barbados Street
George W. Delaney
14½" x 21"

Still Life #1116
Kent Addison
22" x 30"

Superimpose Objects on Another Space

"I paint precise images of each object, true to every detail," says Kent Addison of his paintings. "I also deal with symbolism because I use symbols to imply abstract ideas. My main objective is to construct a synthesis of the natural, the abstract, and the imaginary, and so bring into existence a language of personal symbolism." *Still Life #1116* is from a series of paintings that used common "themes of art" as backgrounds; here a seascape appears. Addison likes to superimpose objects on another space, setting up a dual image

as part of his plan to "hook" the viewer so the deeper meaning behind common objects can be discovered. He actually attaches each object he paints to a flat surface exactly the same size as the paper on which he will paint, working out his composition intuitively until it seems right. He then paints from direct observation, using no "gimmicks." In this painting, Addison especially liked the extreme contrast between the background image and the objects on it, and the way they work together as a whole composition despite their disparity.

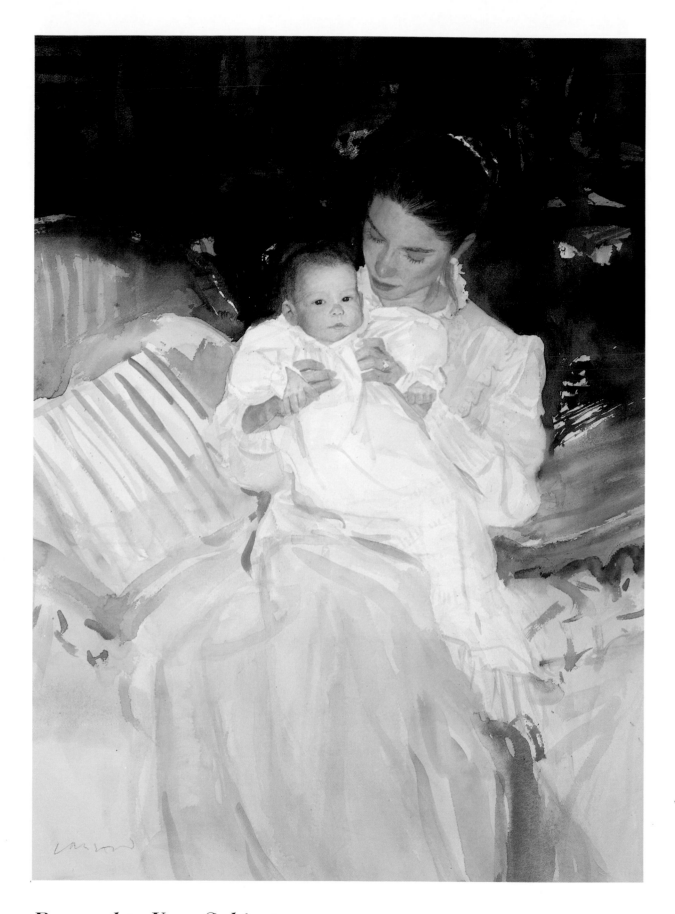

Respond to Your Subject

Though Casselli has mastered the principles of design, when he goes to paint, he gives little conscious thought to those things. As he says, "What is before me and what is inside of me governs all." *Where's Papa* is more a portrayal of the relationship between the mother and child, than it is a portrait of the individuals. The lost and found edges and fluid brushstrokes animate the work, but the faces are more completely stated, thus focusing attention on the interplay between the baby and the mother.

Where's Papa
Henry Casselli
29" x 21"

LIGHT

Light is everything. It's the source of all visual experience and inspiration. It creates value, color, texture, and enables us to see form. But the impact of morning colors lighting up the sky, or of a subtle evening mist, goes beyond these facts. Light reveals beauty, and the inherent emotions of joy and wonder, the foundation of creativity. It is no surprise, then, that capturing and celebrating the infinite variations of light is the ardent pursuit of so many painters. The paintings in this chapter represent natural and artificial lighting situations, but all reveal watercolor's intrinsic glow.

"The sun will not rise or set without my notice, and thanks."
—*Winslow Homer*

Staircase in Ocean City, N.J.
Stephen De Santo
29" x 19"

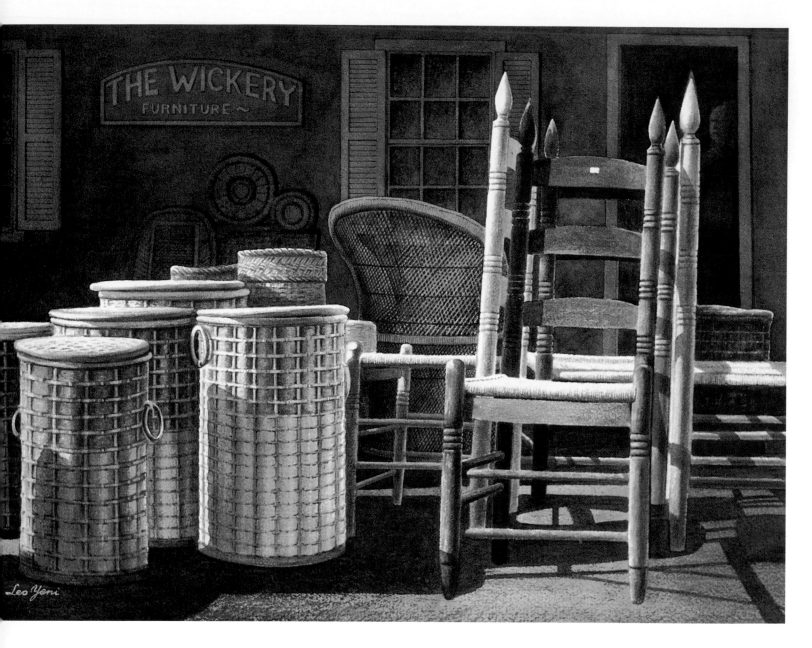

The Wickery
Leo Yeni
26" x 34"

Let Your Background Recede

The Wickery was painted around four o'clock in the afternoon, when the rays of the sun strike the earth at an acute angle. The wickerware on the sidewalk outside a furniture shop in New York created a pattern of strong contrasts of bright sunlight and dark shadows. The surfaces bathed in full sunlight catch the eye, and the repetitive patterns make the eye linger. A few neutral washes of ultramarine blue and gray colored the quiet background of this painting. It was warmed with some burnt umber to keep the shadows from contrasting too much with the wicker. The background establishes the overall mood of quiet reflection, inviting memories of times past.

Accentuate Contrast

Artists are inspired in different ways by the countless effects light has on our environment. Pat Malone's work is all about light and shadow, which she accentuates for the sake of design and pattern. In *Five O'Clock Shadow*, the pattern was achieved by carefully re-creating the design of the light, simplifying and unifying many small areas. The overhead view accentuates the abstract qualities of the chairs and shadows. She says, "I find that an overhead perspective emphasizes this interest [in design] and enables me to create a new approach in depicting ordinary objects."

Five O'Clock Shadow
Pat Malone
25" x 30"

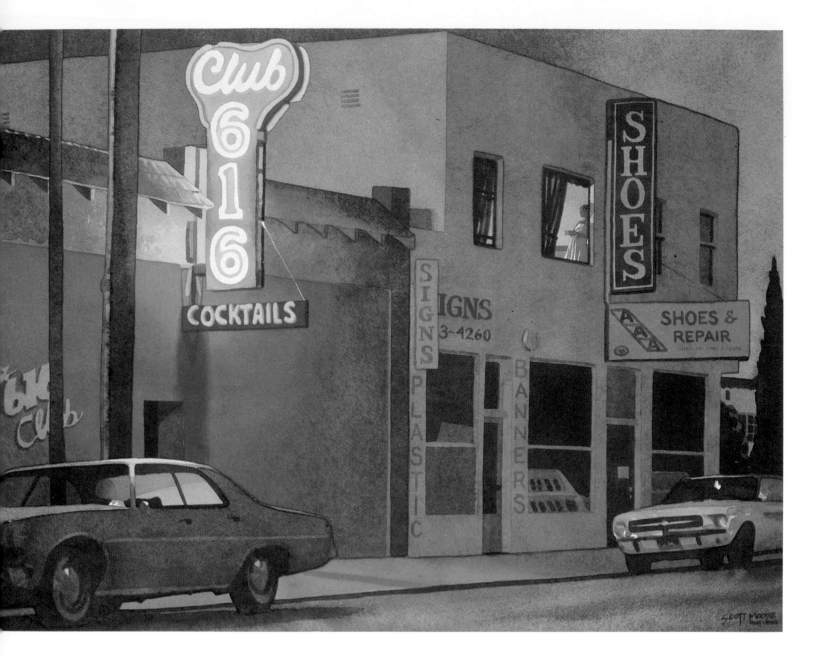

Club 616, Santa Ana
Scott Moore
22" x 30"

Explore Unusual Lighting Situations

Moore has been fascinated by light and cast shadows since he was a child, when his father used to take him along on weekend painting excursions. Moore's work usually focuses on people, but in this painting, his subject is the intensity of color in the light given off by the neon sign, and how it affected the mood of the whole scene. He used only a few colors with a lot of French ultramarine blue in the shadows. This limited range of tube colors made the objects all appear to be illuminated by the same source.

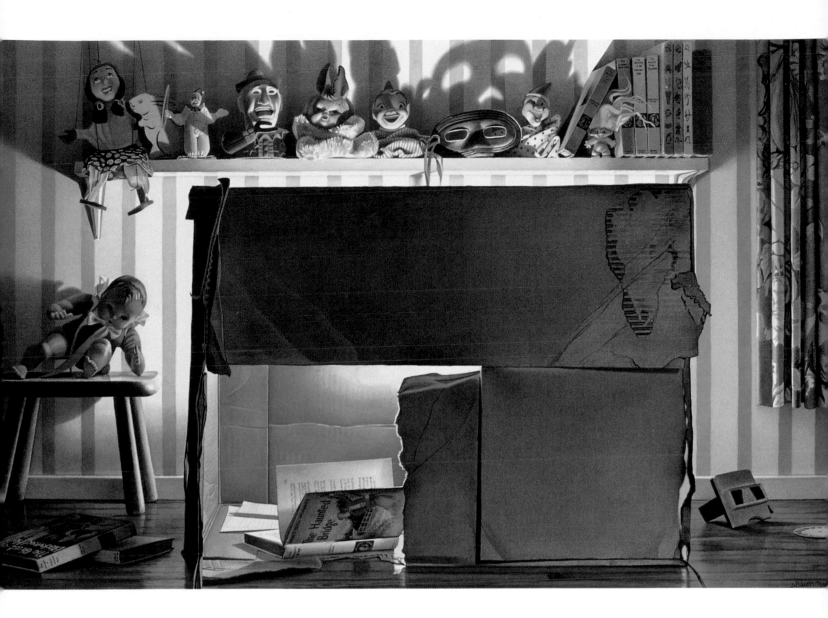

Make Magic with Light

In Maczko's Mind at Play series, she
wanted to involve the viewer in the
make-believe world of the painting.
However, in order to create a magic
mood, lighting is of the utmost impor-
tance. She closes off all the natural light
and carefully places her lights as a
photographer would. Backlighting has
proven to be one of the most effective
techniques. Placing the unseen light
source behind the objects creates silhou-
ettes and auras, all of which conjure up a
sense of secrets and hidden places.

The Mind at Play #10
Sharon Maczko
23" x 37"

Church in Sicily
Michael P. Rocco
18" x 24"

Light for Emotional Impact

Lava flowing from erupting Mt. Etna severely damaged the church that originally stood here. When the church was rebuilt, the stained glass windows were installed quite high, causing a beautiful ethereal light to filter through in a downward diagonal direction. This had such an emotional impact on Rocco that he knew right away he wanted to get the same feeling across in a painting of the scene. In order to reproduce the sense of light coming from above, he worked the composition so viewers would have to "look up" before the dramatic shadows carried their attention down to the minute figures of the nuns. But the strong directional light is by far the most important element of the painting, giving it impact beyond mere representation. The light expresses the artist's view of faith in cooperation with human frailty.

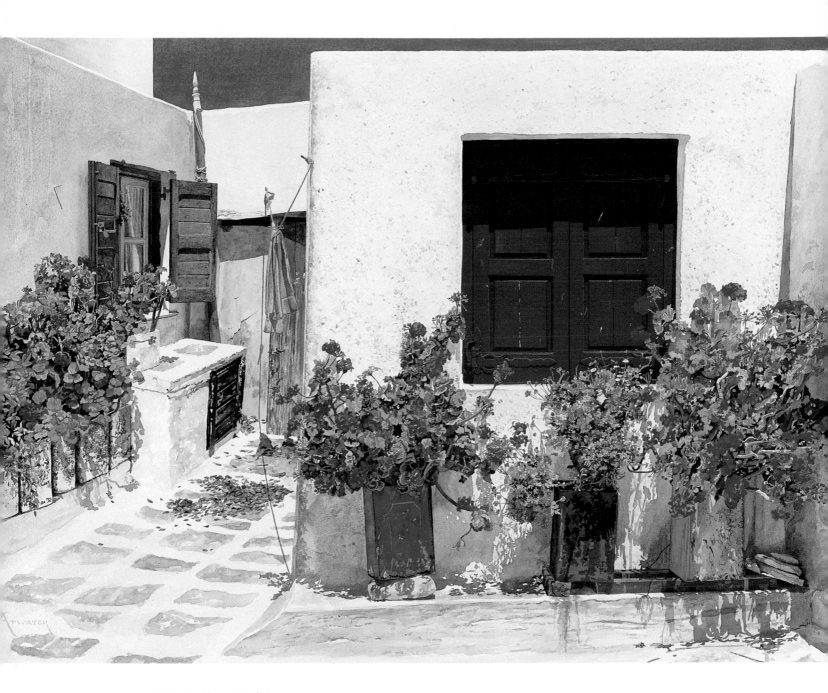

Juxtapose Bright White and Pure Color

Mykonos
John Atwater
26" x 37"

A traditional painter's axiom says that intense light washes out intense color. But in *Mykonos* the primary impact of the painting is in the juxtaposition of bright white and pure deep colors, all saturated with light. The value range is quite broad, which, along with the colors, creates the striking contrast of the image. Atwater accentuated the hues in the plants, sky, and window by using the same hues in the shadow areas, rather than using grays. This further intensifies the feeling of warm, color-saturated light.

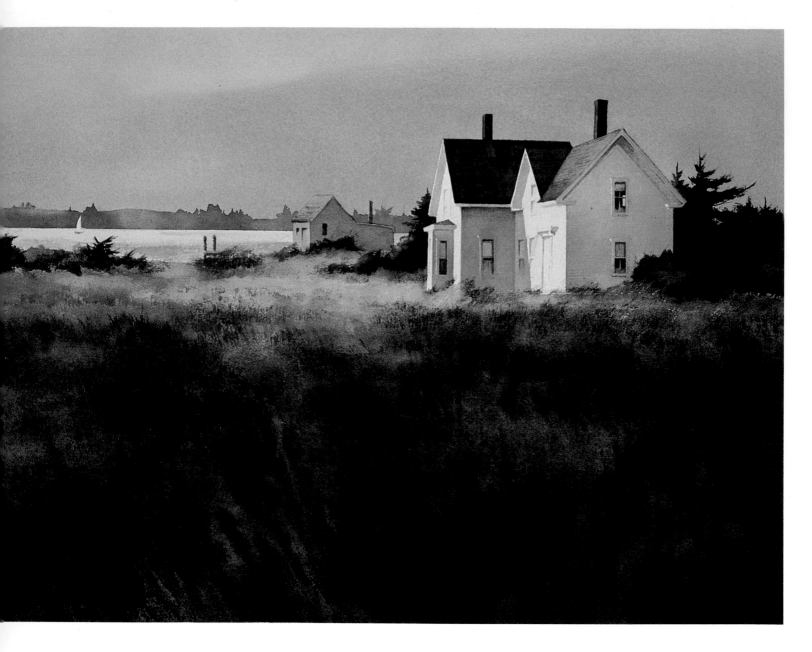

Spruce Cove
Joyce Williams
22" x 30"

Produce Atmosphere with Glazes

In this painting of a summer day in Maine, Williams wanted to translate the visual reality of looking through "layers of atmosphere" onto her paper. In her words, "We see everything through a glaze, translucently." In order to achieve this effect, she applied numerous glazes to each part of the landscape, being careful to keep her colors transparent. She started with warm washes for the foreground. She then used cooler washes for the middle and backgrounds, as objects receded and got more indistinct. Some of the grasses have five or six glazes, giving the effect of overlapping into distant fields. Effective value and color temperature contrasts at the house, distant water, and grasses impart the glow of sunshine to the painting.

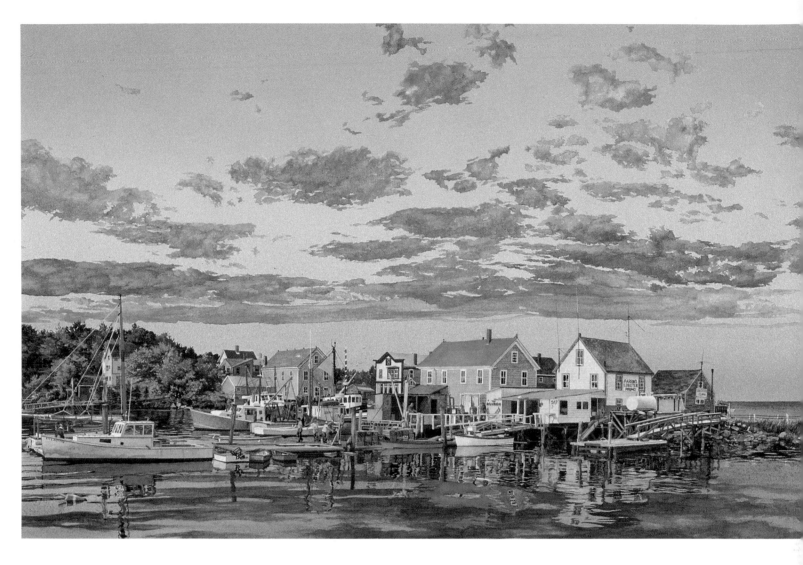

Make Light Your Subject

The idea behind this painting was to
present an architectural scene beneath a
vast panorama of clouds, illuminated by
an early morning light. The sunlight
bathes all of the surfaces in its path with
a glow created with cadmium orange
and burnt sienna. The shadows assume a
complementary hue, reflecting the
cerulean and ultramarine blues of the
sky. The composition makes the sky a
focal area and not just a background.
It is one of three horizontal areas (land,
water, and sky) that remain distinct, yet
allow the eye to move into the painting
to experience the majesty of nature
expressed through the illuminated
clouds. Atwater says, "In many of my
landscapes the atmosphere and light
hold as much importance in the overall
composition as the landscape and
architectural elements."

Early Morning
John Atwater
23" x 34"

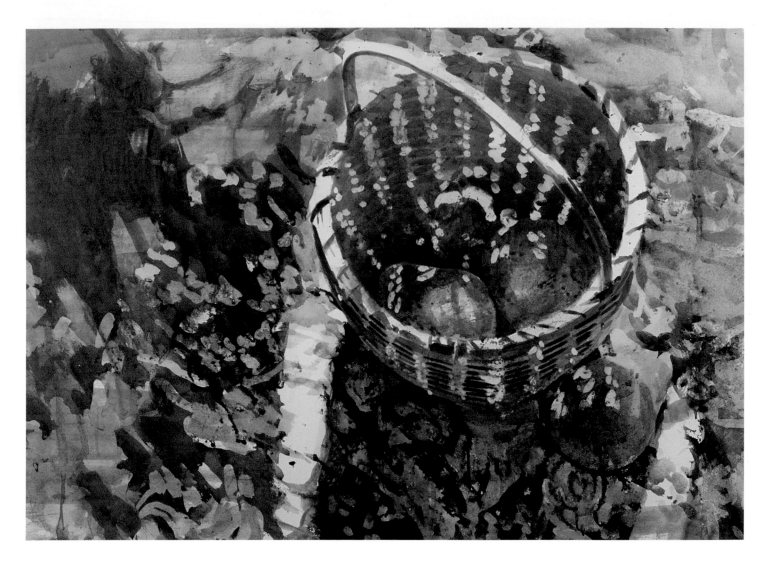

Pears
Dee Knott
32" x 40"

Maintain the White Paper for Sunlight

Dee Knott is very excited by light and by the patterns that light makes. She found the pattern created here an appealing subject, as light came through a window and fell on a woven basket. When she added the pears, she noticed how they intercepted the light from the basket and made it come alive with fascinating patterns and shapes. Preserving the white of the paper was very important to convey the look of sunlight. "It gives me great pleasure to paint an ordinary thing like a pear and a basket, and make them important," Knott says. "We look at many things and never see; art is seeing and feeling."

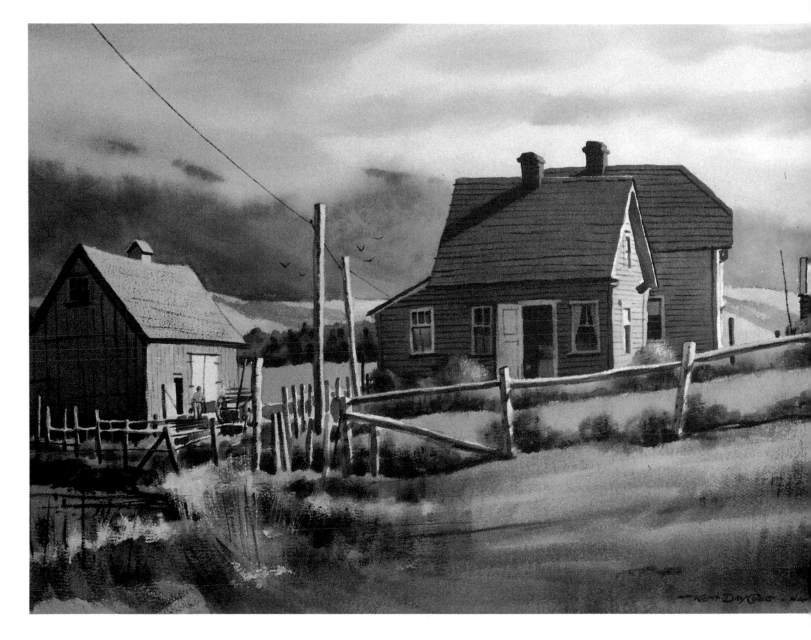

Work Outdoors to Catch Nature's Subtleties

The time of day or season suggested in a painting is largely the result of the way the artist has captured the light in a landscape. An artist must make a conscious study of the way light changes with the time of day and with the seasons and atmospheric conditions. Only the careful observation of nature can teach the subtleties of light. Coes finds on-the-spot painting indispensable for capturing light.

"I am a landscape painter, a tradi-tionalist, and work almost entirely from nature," says Coes. "I do small watercolors on the spot, carrying them as near to completion as possible. Those that seem to lend themselves to a larger concept are later enlarged in the studio. Working outdoors is often uncomfortable and always frustrating, but I know I cannot get along without it. There is no good substitute for being surrounded by nature and absorbed in it."

Morning Mists
Kent Day Coes
21" x 29"

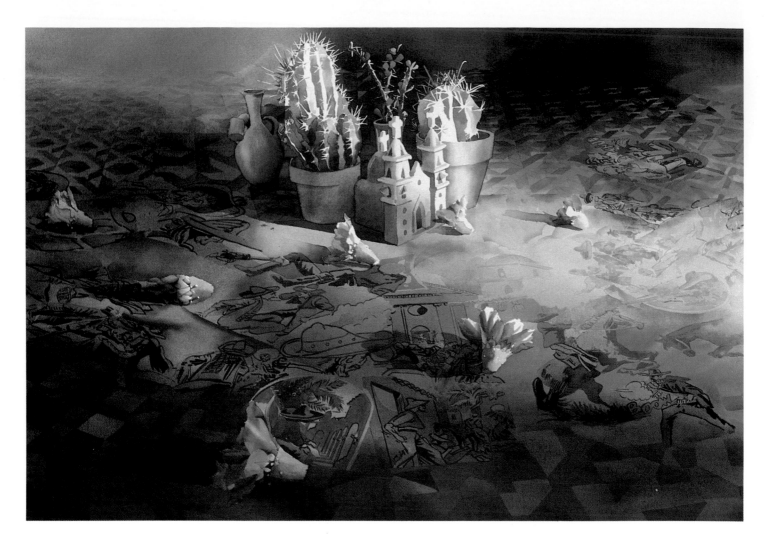

Ojinaga #2
Warren Taylor
40" x 60"

Create an Imaginary World with Light

Ojinaga is a remote barrio clustered on the south side of the Rio Grande, drawn together for reasons of survival in the unforgiving great Sonoran desert. This work attempts to express the same forces drawing together the forms in the painting. The clustered objects are illuminated by a thin shaft of light from a horizontal direction, reminiscent of the gentle, color-enhancing light of dawn or evening in the desert. Though some would call this a still life, the quality of light creates a landscape setting for the objects.

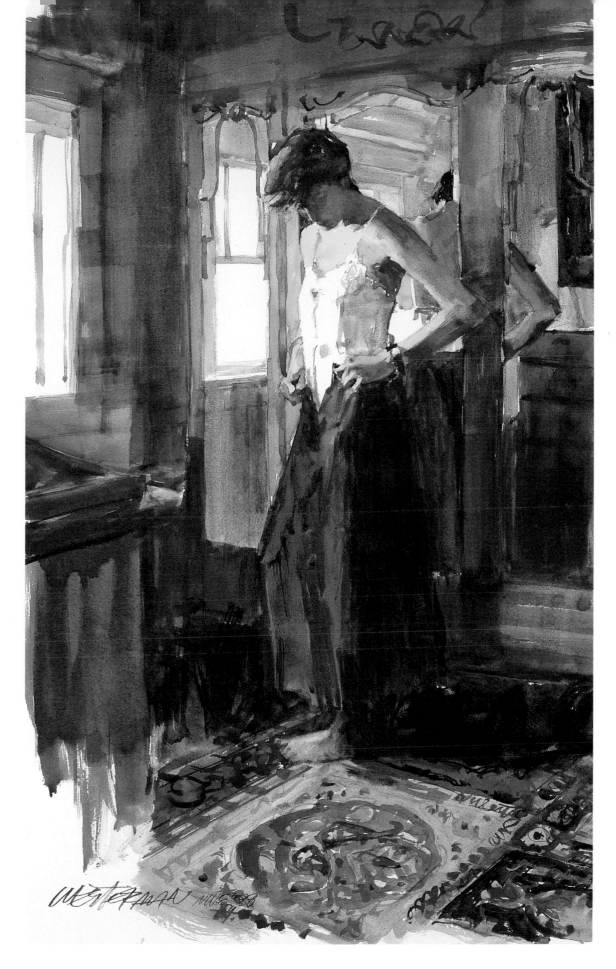

Cast Warm Shadows

The consistent themes in Westerman's paintings are light and people. In this painting, the light from a bedroom window casts strong, warm shadows on the figure, suggesting a mood of intimacy.

Carol's Antique Wardrobe
Arne Westerman
26" x 16½"

MOOD

omewhere in the painting process an elusive transformation occurs when brushstrokes on paper suddenly become a painting. This transformation becomes even more magical when the painting takes on the ability to arouse our emotions and establish a particular mood. It is magic because there is no way to adequately explain it or teach it. Drawing, design, and color theory, though not easy to master, can be taught, but how to create a mood must be learned anew for each painting. It is a private affair between the painter and the painting. It is this quality, which by-passes the intellect and cuts right through to the heart, that causes one to "fall in love" with a painting.

"To wake the soul by tender strokes of art."
—*Alexander Pope*

Jaye and Abernathy
Linda L. Stevens
49" x 33"

Tapestry: Flower Fields
Elaine L. Harvey
30" x 22"

Convey Mood in Abstraction

The flower fields above San Diego were the inspiration for this work. Every spring they form bands of pastel color resembling a tapestry, one of Harvey's favorite formats. In addition, this paint- ing refers to spring itself with its promise of eternal renewal, seen in the repeated bands, the brightness of sunlight, and the sparkle of bronze powder.

Transparent Washes Create a Sunny Mood

Cobb created the impression of a warm, hazy summer afternoon with a series of loose washes gathered over a period of several days. She constantly adjusted colors, shapes, and tones. The resulting variety of edge quality adds visual movement and glow. The transparency is offset and stabilized by the hard-edge, darker shapes of the chair back and the spaces between the rails in the background. Says Cobb of her paintings, "I like to think that my work, when it is successful, has a clear and luminescent quality that glows with an inner light and takes full advantage of the watercolor medium."

Summer Afternoon
Ruth Cobb
29¼" x 29½"

Studio Interior
Thomas A. Nicholas
15" x 23¾"

Suggest Emotions with Edge Treatment

The inspiration for this painting was the cold light falling on the warm color in the south end of Nicholas's studio. This warm-cool relationship with its full complement of values, especially strong darks, produces the richness of tone and the drama the artist prefers in his work. He likes to contrast sharp-focus refinements with soft, diffused areas. In *Studio Interior*, the artful use of edges creates an element of mystery. Though he works in a representational mode, Nicholas believes that "suggestion through edges goes a long way to give a subject its provocative and emotional content."

Suggest Emotion with a Human Subject

Westerman likes to capture a certain quality of light. He arranges this and other elements, such as pattern, color, and texture, around an individual person. In doing so, he evokes a particular mood that he and the viewer can identify with. Here, light filters into the dimly lit train station, throwing lacy patterns in its path. He exaggerated the strong light and deep shadows, and eliminated anything he felt was not necessary for the composition, to keep his statement as direct as possible. He keeps his characters' features somewhat indistinct and the intensity of the colors low to enhance the mood.

Grand Central Station
Arne Westerman
24" x 35"

Hathorn Point
Joyce Williams
22" x 30"

A Sense of Movement in Neutral Colors

Simple colors, vibrant darks, and high contrast are the elements Williams uses in *Hathorn Point* to produce its somber mood. There is a feeling of fluid motion both in the sky and in the foreground where the snow fence rushes up the incline toward the house. The limited palette of dominantly neutral colors sets the mood, while the sense of movement adds excitement, suggesting wind blowing before a storm. She used strong darks to give the painting structure and design, such as where the dark band of trees behind the house helps to anchor the subject.

A Sense of Deep Space

In *The Sand Road*, artist Kent Day Coes has marshalled his watercolor techniques to invoke a powerful mood. First, he relies on a cool color scheme to establish the calm and quiet of the scene. Then he skillfully adjusts the edges to create a sense of deep space, inviting the viewers' eye into the landscape. Notice how quickly the edges soften and the amount of detail diminishes as the shapes recede into the background. The distant trees are merely soft hints in the fog. Finally, the flying gulls on the left and the skeletal trees on the right act as focal points that keep the eye bouncing back and forth inside the composition. Although the sea is not visible in this painting, it is quite evident that it is nearby. The drifting fog and the sea gulls speak of its presence.

The Sand Road
Kent Day Coes
21" x 29"

Saturday Morning
Donna Zagotta
20" x 28"

Capture the Magical Qualities of Sunlight

"I wanted to capture the magical qualities the sun had imparted to the room... the enchantment of a room bathed in morning sunlight," Zagotta says of *Saturday Morning*. The strong dark values contrasted with brilliant lights to create a haunting mood. The sunlight coming through the window both reveals and dissolves the forms it shines on. To create this effect, when the paint on the shrubbery, drapes, and window crossbars was dry, the artist scrubbed areas with a toothbrush in a circular motion, blending the colors together, lightening and softening the forms to almost white. The elements of the painting all work together in an uncomplicated manner, allowing the viewer to enjoy the expressiveness of the painting.

Express the Mood of a Garden

"These peonies are from my garden, which has been a part of my life for as long as I can remember," says Margaret of her painting, *A Burst of June*. "The setting is expansive. The spirit is calm and serene. I wanted to stage the magic grandeur and vigor of these flowers in their natural environment...Flowers are fragile but there is a feeling of power and strength to these peonies." In order to capture the immediacy of the setting, Martin exaggerated the contrast of the flowers against the background, creating a flickering pattern of dramatic light and dark shadows. The flowers' radiance was produced by juxtaposing the three primary colors.

A Burst of June
Margaret M. Martin
22" x 30"

Refinery Rhythms
Albert W. Porter
15" x 22"

Refine the Essence of a Scene

The mood in a painting is often the product of very deliberate decision making. In *Refinery Rhythms*, the mood conveyed is the result of the artist's manipulation of all the elements of painting. It was inspired by a real refinery, but is a loose interpretation of the actual scene. The artist was attracted to the sense of power and energy latent in the rhythmical qualities of its forms and chose to express this rhythm by movement and repetition. The movement of the steam and smoke shapes directs the eye horizontally against the repetition of the vertical shapes of the refinery. The shapes of the refinery were exaggerated to enhance this vertical effect. The crisp edges of the machinery contrasts with the amorphous shapes of steam and cloud. The colors of the sky and distant towers are a bit brooding, but they are balanced by the warm intensity of the foreground towers. Finally, the figures provide a scale of reference, and by contrast make the refinery look even more imposing.

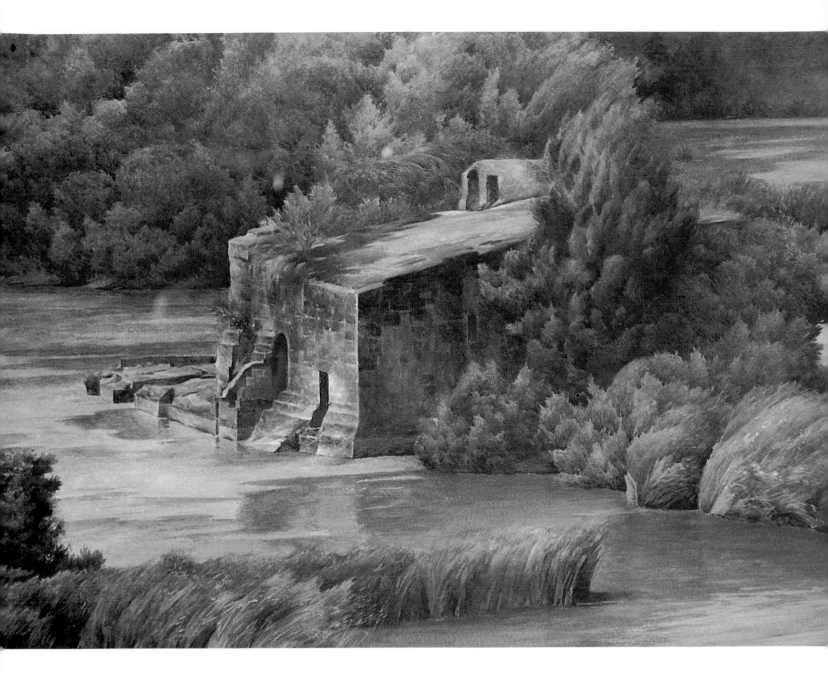

Paint a Rosy Glow

Creating a mood can sometimes be as simple as capturing a time of day, especially if the particular scene is romantic or fanciful in itself. In this painting, Worthman laid down a light crimson wash over his whole paper to re-create the "rosy glow" that permeated this unusual scene in Madrid. This rosy wash, in turn, influenced all subsequent colors to harmonize the three elements of water, foliage, and masonry. Worthman feels it is best to use as simple a palette as possible to aid continuity. He says, "Nothing exists by itself but is influenced by and dependent on everything else." Traveling is Worthman's favorite source of inspiration. "To capture a mood, the poetry of the locale, the tapestry of forms and color, a moment in time—these are my goals."

River Island, Madrid
Moses Worthman
21" x 29"

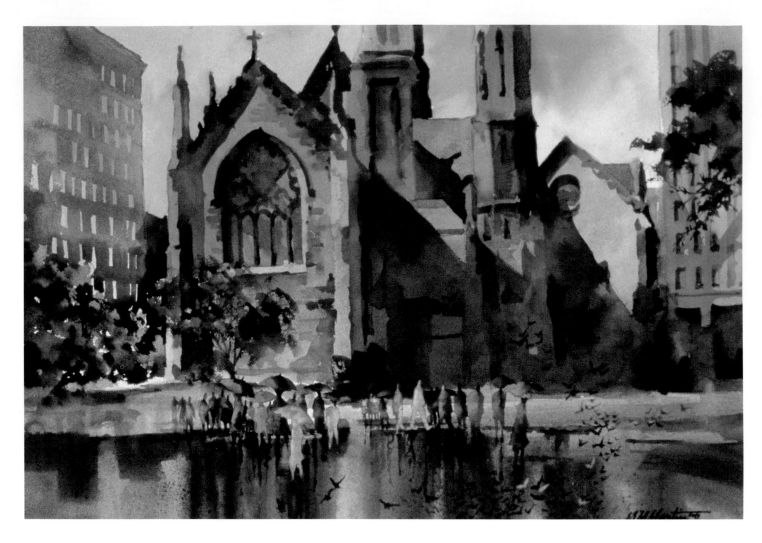

Sunday Morning
Margaret M. Martin
22" x 30"

Isolate the Immediacy of the Moment

Martin has lived and worked in the city for most of her life and sees it as a stage set ready to come to life in a burst of excitement and drama. She likes to paint the many moods that are created by the relationship between glowing light and dark patterns. In this cityscape, Martin was responding to the sounds of ringing church bells as well as to the grand historic architecture. She reduced the size of the people to dramatize the massive church structure. "There had been a light summer shower," Martin says of the scene. "The sun appeared for a few brief moments. I wanted to create the immediacy of the moment."

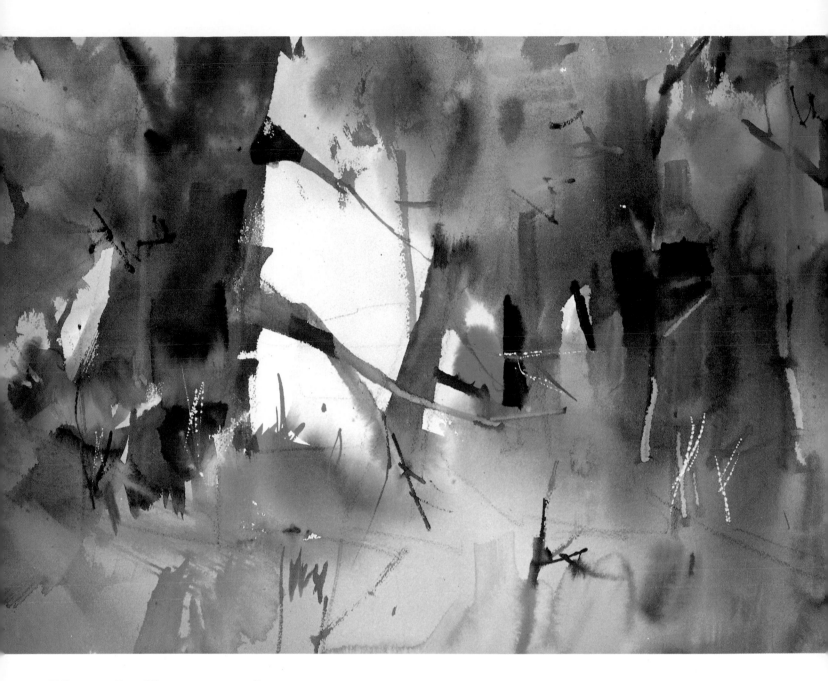

Place the Viewer in the Painting

Webb is not known as a "mood" artist. But in this painting of a forest interior, the wet patches of rich color give the viewer a clear sense of the damp darkness of the woods. The foreground comes right up to the viewer, giving the illusion of standing in the shaded bracken, while the open white space leads us even further into the space of the painting. Webb further enhances the mood by his use of a predominantly low (dark) key, which quietly surrounds the one bright area.

The Clearing
Frank Webb
20" x 30"

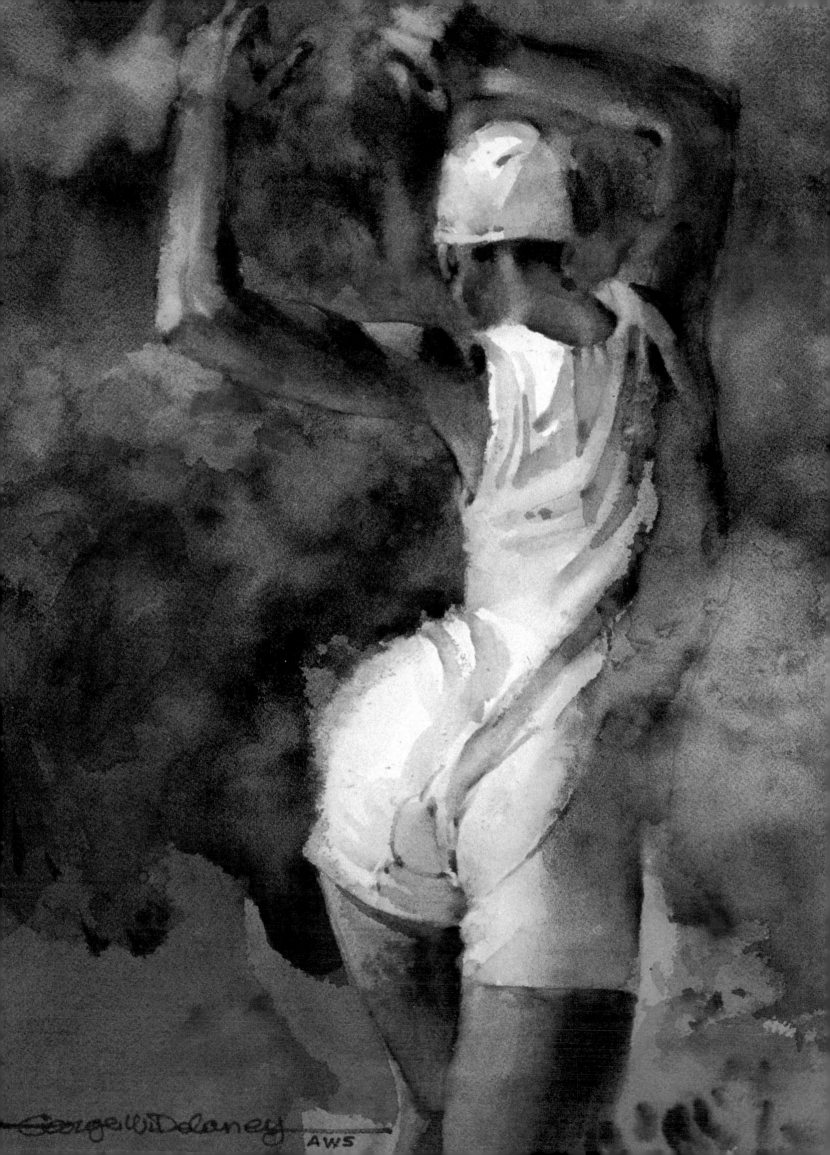

CREATIVITY

Creativity is perhaps the only human resource without limits. It is a universal human ability, not the exclusive possession of a lucky few. We are all creative. Those of us who choose to be creative in the visual arts use that ability to see in an original way and to transform that vision into paint. The limitation we then confront in the medium can be a source of frustration, or it can serve to focus and communicate the artistic vision. Watercolor is a wonderfully flexible medium, responsive to any direction in which the artist chooses to go.

"No bird soars too high if he soars with his own wings."

—Anonymous

Dancer
George W. Delaney
14½" x 21"

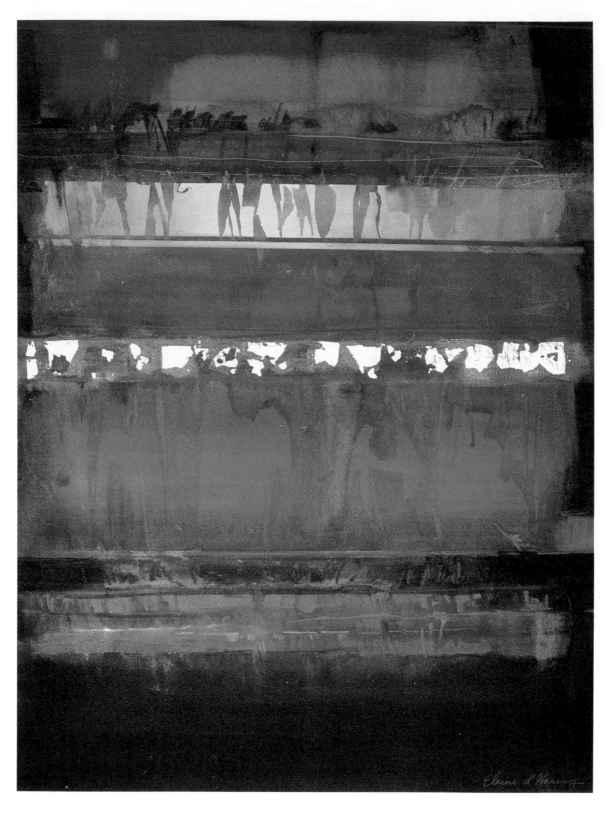

Tapestry: History Lesson
Elaine L. Harvey
22" x 30"

Present Your Views with Paint

This painting is part of Harvey's current Tapestry series. She often expresses the idea of the passage of time by repeated bands. These horizontal lines represent a time line, while the abstract shapes refer to the machines of war used throughout history. The red, white, and blue are colors she associates with American history class. Harvey's message is that war is futile. The strong emotions sur-rounding the subject of war are suggested by the brilliant primary colors, and the broken shapes of metallic leaf represent the broken implements of warfare. Because Harvey's paintings are abstract they are subject to the viewer's own interpretation. She sees this as a positive thing because it involves the viewer in the process.

Allow Your Work to Evolve

Recently, De Santo, who has painted photorealism for years, went to a completely abstract form in his work. In discussing this change he says, "Years ago, when I learned to paint in a tight, very exacting style, it freed me to deal with subject matter in a way that best fit my analytical nature. Painting photorealism permitted me to examine and celebrate the world as I see it. As I got older and the years began to fly by, my interest in the look of the physical world began to fade. The importance of ideas began to dominate together with a desire to experiment more."

De Santo uses a checkerboard as a matrix for his current work. The matrix, being so basic, gives open-ended possibilities for composition. The look of a game board also serves as a metaphor for life as a game. De Santo experiments with the interplay between the visual and the conceptual aspects of this matrix.

Aqua Awning in Ocean City
Stephen De Santo
28" x 38"

Abstract #4
Stephen De Santo
7" x 14"

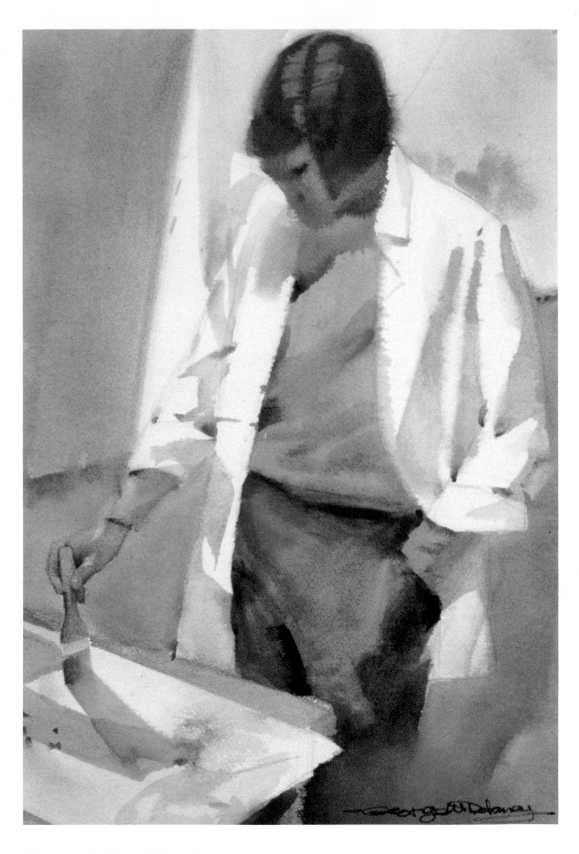

Mei Ki
George W. Delaney
14 1/2" x 21"

Paint What You See and Know

Delaney gets most of his ideas from what he sees around him or from his other paintings. This simple but strong painting of an Oriental artist is one example of how mundane subject matter can inspire an elegant painting.

Let Your Materials Inspire Ideas

Moore recounts, "When the Laguna Art Museum sent me a piece of Mylar and asked me to use it as inspiration for a piece of art, I laid it on the table in my studio and looked at it. The reflective quality of the material along with another meaning of the word 'reflecting' brought an instant image to my mind. I had always wanted to float objects around a room, and now I had the chance to float them on pieces of Mylar. The objects would represent pieces of my past works, and I would paint a portrait of myself fishing on a windowsill, while viewing my portfolio as it heads out the window. It was a new way of taking a last look at my past before embarking on a new direction."

Reflecting on Paintings Past
Scott Moore
18" x 20"

Women in Flower Shop
Yee Wah Jung
42" x 54"

Let Colors Run Their Own Course

Jung comes from a family of artists. Her mother's mosaic painting has been a strong influence and Jung has always been fascinated by decorative art or design of any kind. When she paints, she thinks of color first. She begins by selecting two colors, which she dabs here and there, moving the paper around then allowing it to dry. She then retraces the maze of color with other colors and lets them run their own course. She works toward a kaleidoscope or mosaic effect, a jewel-like world.

Imagine a Painting

"The two most fertile sources of ideas are the painting on which I'm working and a kind of self-hypnosis or daydreaming," Cadillac says. She will stare at a peaceful scene, concentrating on nothing in particular, allowing her mind to wander. Then without her being aware of the process, her mind will suddenly fix on a subject or idea as she brainstorms with herself, keeping a note pad and pencil handy. In her Stone series the recurrent theme is confrontation. The central stone shape captures the eye and boldly confronts the viewer. Cadillac is always experimenting with new ideas to make her work daring and unorthodox.

Stone Series #81
Louise Cadillac
30" x 22"

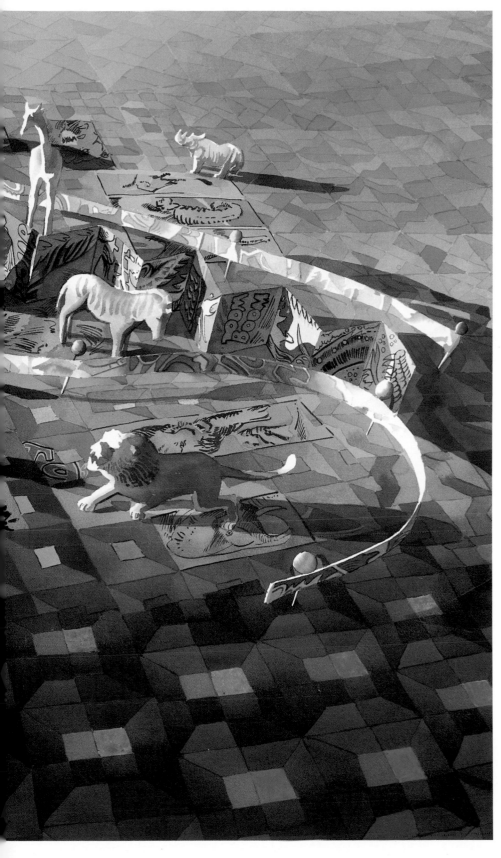

Make a Still Life into a Landscape

Taylor has used a game board setting to cluster a group of animal objects drawn together by "human schemes, devices, and geometry." He gives the painting the atmosphere and light of a landscape, stimulating the imagination. He also uses color in a playful way by taping out one or more random shapes and waiting until the very end to paint these, usually in a wild color. Note the glowing red-orange squares in the lower left foreground.

Sanguine Savannah
Warren Taylor
40" x 60"

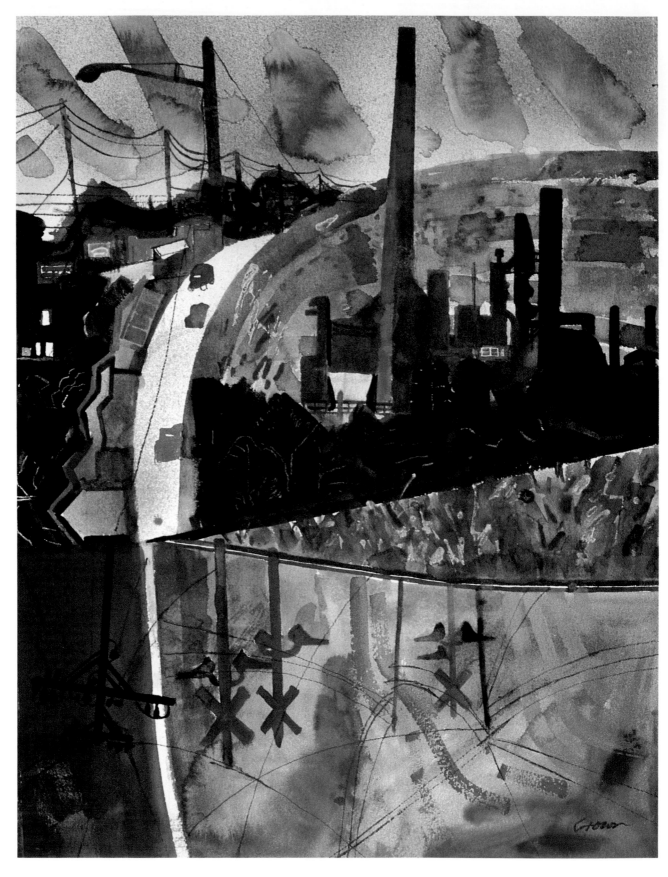

Columbia, MO
Electric Plant
Keith Crown
30" x 22"

Place Yourself Within the Painting

Years ago, Crown experienced a break-through in his painting when he decided to use a curved horizon, placing him in, rather than in front of, his subjects. This painting is an outgrowth of that idea. A diagonal line divides the painting into what is in front of the artist and what is behind. The forms behind him are rendered upside down. Crown did this painting on location so the direct experiences of sight, sound, and smell would all be part of the creative process.

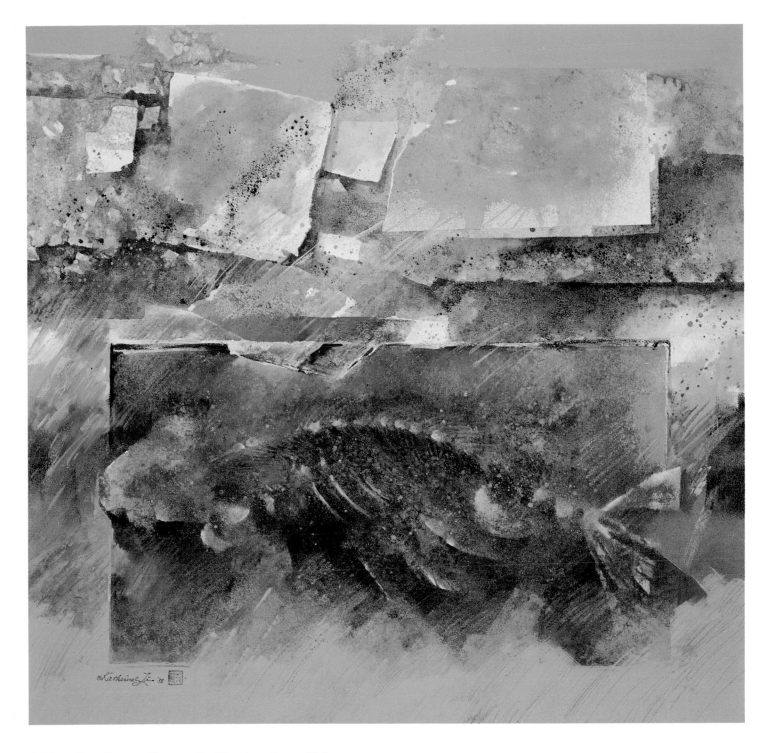

Words Can Spark Painting Ideas

Liu keeps a little book in which she jots down random thoughts, some of which eventually become concepts for a painting series. Even when working with a more representational subject, she approaches it conceptually, rather than from direct visual data. The Chambered Relics series came from an idea she jotted down about a year before any visual idea came to mind. Her current interest is in the mystery she associates with ancient cultures. To achieve a mood of mystery in this painting, the colors are grayed down so the bright colors seem to seep through layers of texture.

Chambered Relics #2
Katherine Chang Liu
36" x 36"

Left, Please
Rolland Golden
22" x 30"

Notice What is Often Overlooked

Ideas for paintings can be sparked by objects we see daily but never really notice. Golden says, "The concept behind *Left, Please* was to superimpose a mass-produced road sign in front of nature—to the point where it totally dominates the viewer's eye. At the same time I have tied the sign into its environment through interacting planes and color harmony." The exaggerated importance of the sign indicates how such small objects interfere with our perception of nature.

Generate Ideas by Beginning

This painting is a part of a whole series of "window and door" paintings. Lupinek explores the sense of the existence of another world "beyond" or "out there" in order to evoke a feeling of expectation or longing for a better place. Various geometric shapes have been the basis for many of Lupinek's experiments. The artist generates ideas simply by begin-ning. One mark naturally leads to the next and "each move prompts a counter-move, just like a dance, or a melody, until the piece is played out. Some of these moves seem merely instinctive. If they lead to a favorable conclusion I use them again and again, until a new way of working takes over."

Twin Pix
Evani Lupinek
22" x 30"

PERMISSIONS

INDEX